101 THINGS TO DO IN
MARTHA'S VINEYARD

Gary J. Sikorski

Schiffer Publishing Ltd

4880 Lower Valley Road • Atglen, PA 19310

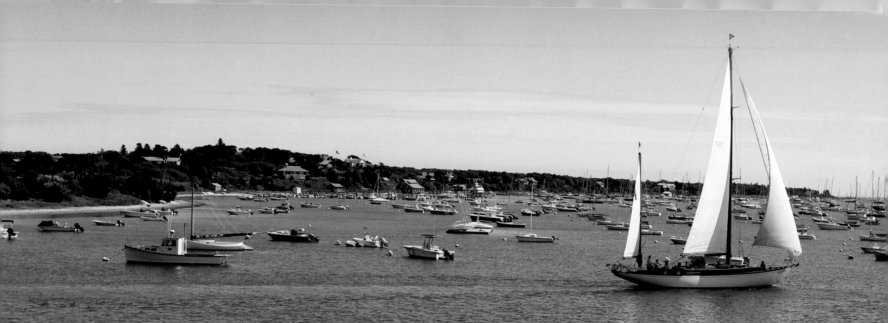

Other Schiffer Books on Related Subjects:

In Every Season:
Memories of Martha's Vineyard,
by Phyllis Meras,
978-0-7643-4095-6

Martha's Vineyard Perspectives,
by Arthur P. Richmond,
978-0-7643-3834-2

Martha's Vineyard: Houses
and Gardens, photographs
by Lisl Dennis and text
by Polly Burroughs,
978-0-7643-2752-0

Library of Congress Control Number: 2015943488

Designed by Brenda McCallum

Type set in Cinzel Decorative/Times Roman

ISBN: 978-0-7643-4953-9
Printed in China

Published by Schiffer Publishing, Ltd.
4880 Lower Valley Road | Atglen, PA 19310
Phone: (610) 593-1777; Fax: (610) 593-2002
E-mail: Info@schifferbooks.com

For our complete selection of fine books on this and related subjects, please visit our website at www.schifferbooks.com. You may also write for a free catalog.

This book may be purchased from the publisher. Please try your bookstore first.

We are always looking for people to write books on new and related subjects. If you have an idea for a book, please contact us at proposals@schifferbooks.com.

Schiffer Publishing's titles are available at special discounts for bulk purchases for sales promotions or premiums. Special editions, including personalized covers, corporate imprints, and excerpts can be created in large quantities for special needs. For more information, contact the publisher.

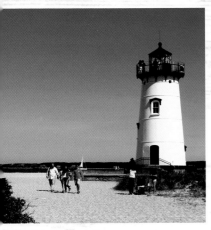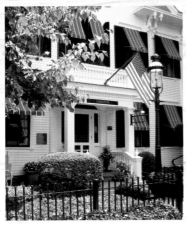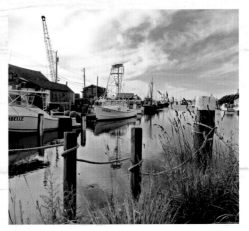

CONTENTS

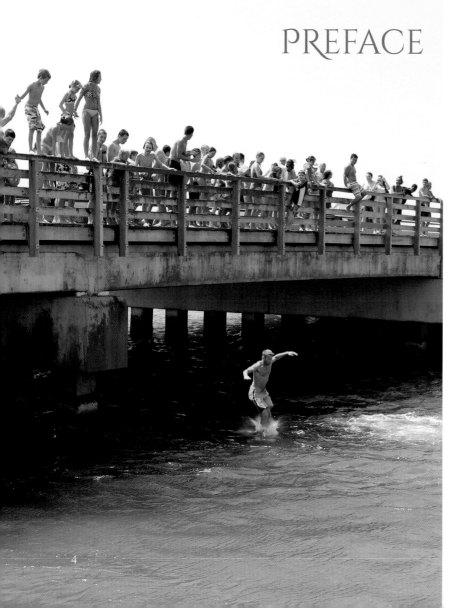

PREFACE

I had been working on Cape Cod and Martha's Vineyard for many summers when several years ago I arrived for the season only to find my rental for the summer would not be ready until the next day. So I checked into a nice little bed and breakfast in Oak Bluffs for the evening. Waiting for the check-out clerk the next morning, I spotted a small corkboard in the lobby that had printed lists of twenty things to do on Martha's Vineyard. "Very touristy," I thought. But as I looked the list over, I realized there were several things I hadn't experienced. In fact, most of the things I did know about, and had even recommended to visitors in the past, but I had always been too busy to do them myself. I decided I must get out and do these things!

As I drove away from the inn down Dukes County Avenue, my mind raced with all the things I wanted to do and see that particular summer season. As I was day-dreaming, I passed a cool, little red building with a small plaque that urged people to shop, and shop for "mostly shoes." For some reason I pulled off to the side of the road and got out of my car and took a picture of that colorful shop. It was right then and there that I thought to myself that there must be a hundred things to do on Martha's Vineyard, and not only would I make a list, but I would take my camera along with me! And so I was on my way to creating *101 Things to Do in Martha's Vineyard*. What started out as a fun, little personal project turned out to be even more rewarding than I imagined. I've tried to capture all the wonderful things to do on the island—not just the traditional, well-known activities, but things the locals like to do as well (like getting a huge lobster roll at Grace Church on Fridays).

Keep in mind, the list is in no particular order. And my only regret is that there are some experiences I had to leave out. My apologies for those I have omitted. So go follow the paths, follow the trails, and most of all, follow your heart.

Enjoy the Vineyard!

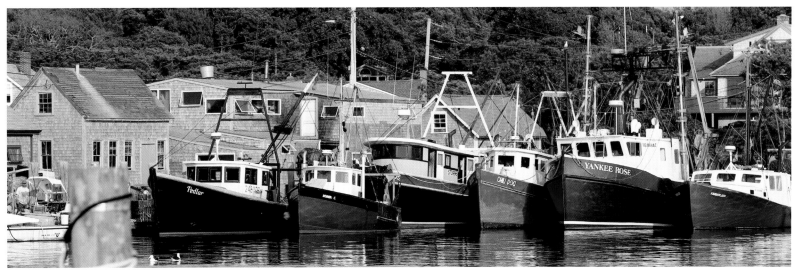

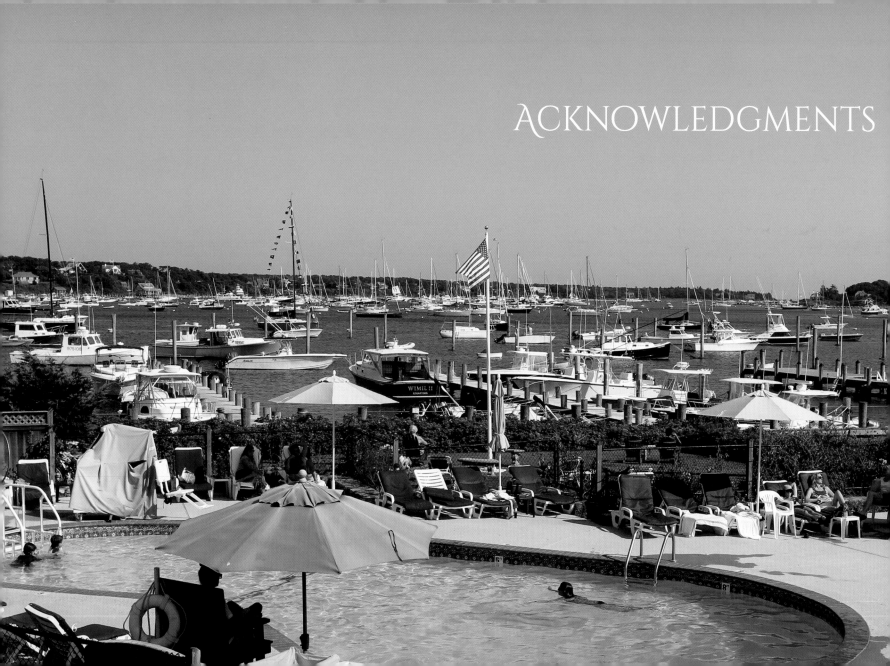

ACKNOWLEDGMENTS

Composing this work over the last several summers was a very enjoyable and gratifying experience, but it could not have been accomplished without the thoughtful help of others, some who were old friends and some who are now new friends. To all of you who helped me along this wonderful journey, I am extremely grateful and forever thankful.

Helping along the way was Collette Royer, who provided her encouragement and proofreading skills. I'm not sure which was more important! My thanks also go out to Brigid Clarke, who, despite her own physical challenges, provided moral support and wonderful suggestions. You are to be admired for your courage and uplifting spirit! To Todd Monjar, many thanks for your help, your photographic advice, and for the admirable shot you graciously provided for my biography. And thanks to my mom, Dolores Sikorski, who kept encouraging me to get this book published! I also want to thank Chris Seidel and the MV Commission for providing the map used in this book. And kudos to all the kind souls on Martha's Vineyard who helped in some small way, providing suggestions, offering comments, sharing thoughts, and allowing me to photograph them. Many thanks to my editor Catherine Mallette for all her help in making this book a reality. And I am most appreciative to Pete Schiffer, who made the phone call to me one day to tell me he wanted to publish my work (how thrilling!). Pete, my heartfelt thanks go out to you and to everyone at Schiffer Publishing. And to the readers, thank you for traveling along with me in this photographic traveler's guide. Even with 101 suggestions, there is still so much more to be discovered on this remarkable, beautiful island. So go explore. Thank you very much everyone!

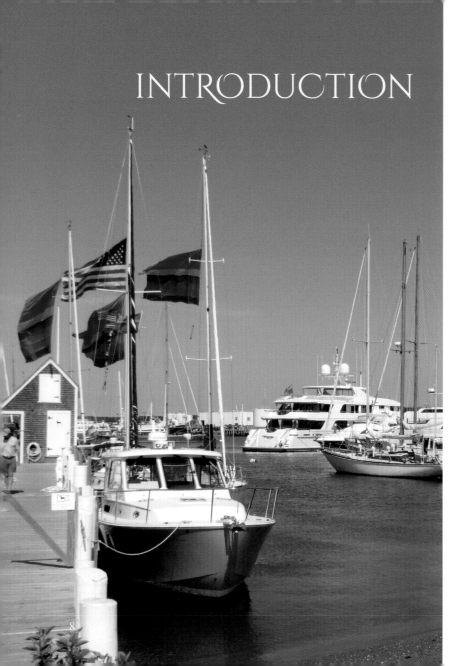

INTRODUCTION

Grab a ticket and hop on the ferry—we're going to Martha's Vineyard! And if you're wondering what to do and when to do it, we've got you covered. You are about to discover 101 reasons why you should visit this summer playground that's less than an hour's ferry ride off the coast of southern Massachusetts. Leave your car on the mainland. This 100-square-mile island is easy to get around on tourist-friendly island buses, by bike, or on foot. It's just five miles offshore from Cape Cod, but this summer paradise with no traffic lights is a long, long way from the workaday world of the city. So put on some comfy shoes and be an islander!

Martha's Vineyard was originally inhabited by the Wampanoag Indians, who have been residing on the island for thousands of years. Originally called Noepe, meaning "land amid the waters," the island was renamed by the English explorer Bartholomew Gosnold in 1602. He named the island in honor of his daughter Martha, and also because of the abundance of grapevines he found on the island. While the vines have withered away over time, the name has remained. Martha's Vineyard was brought to prominence in the nineteenth century due in large part to the whaling industry. Sailing ships left the Edgartown harbor to search the world for whale oil and blubber. Many of the ships' captains eventually called Martha's Vineyard home and built huge Federal and Greek Revival mansions. Just like the grapevines, the whaling industry has faded away, but you can still see many of these well-maintained houses as you stroll North and South Water streets.

Today, tourism is the island's chief source of income. The population is only about 20,000 year-round residents, but that swells to over 100,000 in the summer season when tourists, artists, summer residents—many of whom own summer homes—boaters, celebrities, and US presidents come to enjoy the sun, the refreshing ocean breeze, the many miles of beaches, and all of the island's activities. The many celebrities who

have discovered the island over the years include David Letterman, Larry David, Meg Ryan, Ted Danson, Carly Simon, Adam Sandler, Spike Lee, and Tony Shalhoub. President Bill and Hillary Clinton were frequent visitors in the late '90s. And of course, President Barack and Michelle Obama have been vacationing here most recently.

101 Things to Do in Martha's Vineyard will take you on an informative, photographic journey where you will learn about the popular locations, local favorites, and activities you might have not even known existed even if you are familiar with the island. Also included are interesting tips that will help you make the most of your visit. We'll take you on a complete voyage of the entire island, from pristine beaches to lush wooded trails, quaint island eateries, and active nightlife. We'll show you all six major towns on the island, each with their own personality, and everything there is to do in between. Martha's Vineyard has always been a summer place. So whether you're Down-Island in the more touristy towns of Edgartown, Tisbury, or Oak Bluffs, or Up-Island in the more rural towns of West Tisbury, Chilmark, or Aquinnah, there's plenty to do for everyone!

Discover Edgartown, the largest town on the island; whaling nostalgia runs the full fathom here. The picturesque tree-lined streets are lined with stately, white-clapboard captains' mansions and upscale restaurants and boutiques. The harbor, filled with sailboats and yachts, is frequently voted one of the most beautiful in the world. Take the tiny "On Time" ferry and you can cross the channel to Chappaquiddick Island and see Mytoi Gardens or the Cape Pogue Wildlife Refuge with its towering lighthouse. "Chappy," as it is known by locals, used to be connected to Martha's Vineyard, but sand erosion at the end of Norton Point Beach has caused the small parcel to separate itself from the Vineyard proper.

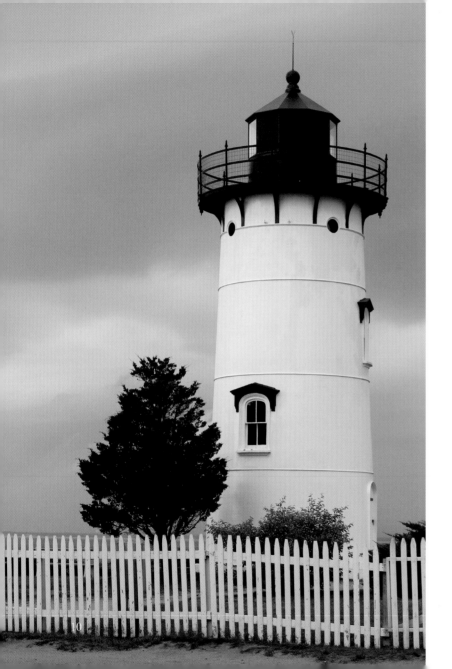

The town of Tisbury includes the main village of Vineyard Haven, the primary port for people, vehicles, and cargo arriving from Woods Hole. The harbor is filled with wooden boats, and you'll find the original Black Dog Tavern here, along with tons of souvenirs with the famous Black Dog logo. The village is also home to the world-class Vineyard Playhouse, as well as Grace Church's famous lobster rolls. Follow Main Street all the way down West Chop and you'll find the US Coast Guard–owned West Chop Lighthouse.

Oak Bluffs has always been most well known for its ornate "gingerbread" cottages, open-air seafood restaurants on the scenic harbor jammed with luxury boats, and the vibrant, active nightlife scene. "OB," as the locals call it, is one of the oldest African-American destinations in the US, thanks to its history as a Methodist revival retreat. Check out the Flying Horses Carousel, the oldest operating platform carousel in the country, and try to grab the brass ring! Stop by Donovan's Reef for his famous frozen Dirty Banana, a drink that's sure to make you smile. And stroll down Circuit Avenue, the busy "main street" in town, where both sides of the street are lined with restaurants, bars, gift shops galore, ice cream parlors, coffee shops, and Ryan Family Amusements packed with arcade games that will keep the kids (and adults) busy for hours. Wind down on the great lawn in Ocean Park with its large white gazebo acting as the centerpiece. From sun up to sun down (and well past that!) Oak Bluffs has got something for everyone.

Heading Up-Island, the landscape becomes more rural and the hustle and bustle from the throngs of tourists are replaced by stunning coastal views, winding and curving waist-high stone walls decoratively surrounding farm properties, and a stunning yet peaceful quiet that rolls over the hills and wildflowers. The towns and accompanying countryside are a bit farther out and best traveled by car, but the buses can get you there just as well. There is much to see and do Up-Island, and you won't want to miss it!

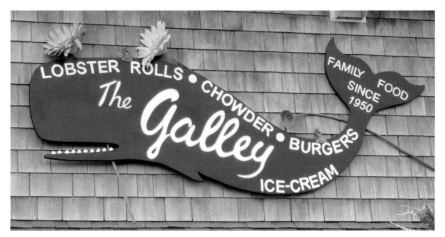

West Tisbury is farm country, with lots of open fields and grazing cattle. This is where you'll find Alley's General Store. Dealers in almost anything, the store opened in 1858 and it's the oldest operating store on the island. You can check out the outdoor sculpture garden here as well, and if it's Wednesday or Saturday, you can go to the West Tisbury Farmers Market for fresh produce, fresh flowers, and so much more. West Tisbury also has acres of state forest, scenic beaches, and a world-class glass-blowing studio.

Chilmark features the hilliest terrain on the island. Most celebrities live out this way, so if you grab a slice of pizza at the Chilmark General Store and sit out on the huge front porch you are bound to rub elbows with a famous person sooner or later. Nearby is where Jacqueline Kennedy Onassis once built a summer hideaway on 400 secluded acres. Chilmark is also where you can find the small picturesque fishing village of Menemsha, which found fame in 1974 when Steven Spielberg filmed scenes of the movie *Jaws* in its harbors. Sunsets in Menemsha are

spectacular, as is sitting on the beach with a freshly steamed lobster from nearby Larsen's Fish Market, enjoying that sunset!

And you can't miss Aquinnah, also known as Gay Head, home to the Wampanoag Indian tribe, the ultra-scenic breathtaking red clay cliffs, and a clothing-optional beach.

While 101 seems like so many "things to do," there are many, many more that could have been included, and many more just waiting to be discovered. Each day on the Vineyard is an adventure, so go out and discover on your own. Marvel at the panoramas. Experience the vistas. Explore the trails. Check out the map on page 14; it will start you on your way. And don't miss the tips for a perfect day on page 13; they'll help you to maximize your enjoyment. Now, go feel the breeze in your hair, smell the salt in the air, taste the butter dripping from a freshly steamed lobster, and hear the horn blowing from the ferry as it pulls out of the harbor.

Turn the page, and let's go to Martha's Vineyard!

A PERFECT DAY ON
MARTHA'S VINEYARD

Very often I'll be asked the question, "I'm only going to Martha's Vineyard for a day, what should I do?" Although there are 101 wonderful things to do on Martha's Vineyard, unless you live on the island or are fortunate enough to be able to spend an entire vacation here, doing all these things in one or two days would be quite unreasonable. If you have one day to spend on the Vineyard, unfortunately you could miss out on the Up-Island activities, like sunset in Menemsha or experiencing the clay cliffs in Aquinnah. But you can still have a wonderful day Down-Island where the three major towns are located. So, for all you day-trippers, here is my plan for a perfect day on the Vineyard.

7:30 a.m.	Arrive in Falmouth, and park your car in the Palmer Avenue lot; take the shuttle bus to Woods Hole
8:15 a.m.	Board the Steamship Authority ferry for the 45-minute excursion to Martha's Vineyard (check the ferry schedule for times)
9:15 a.m.	Enjoy a good old-fashioned breakfast and a nice cup of coffee at the Art Cliff Diner
10:30 a.m.	Catch the bus to Edgartown and take a walking tour of the old dignified whaling captains' mansions
11:00 a.m.	Visit the excellent historical collection at the Martha's Vineyard Museum, which is housed in several buildings
1:00 p.m.	Relax with a Dark 'n Stormy and a bite to eat on the second-floor deck overlooking the harbor at The Seafood Shanty
2:00 p.m.	Jump on the Mad Max catamaran for an exhilarating two-hour sail on the ocean (reserve in advance)
4:15 p.m.	Take the bus to Oak Bluffs, and stroll down Circuit Avenue to do a little shopping
5:00 p.m.	During your stroll on Circuit Avenue, stop in at Ben & Bill's Chocolate Emporium for a lobster ice cream cone
5:30 p.m.	Head on over to the "Campground" and tour the tiny, winding streets lined with their ornate gingerbread cottages
6:30 p.m.	Marvel at your day over a steamed lobster or some fresh sushi at one of the open-air raw bars along Oak Bluffs Harbor
8:00 p.m.	Make a last stop at Donovan's Reef for his famous Dirty Banana and enjoy your drink while watching the sun set in the distance
8:30 p.m.	Catch one of the last ferries back to Woods Hole, and plot your return to Martha's Vineyard!

MARTHA'S VINEYARD

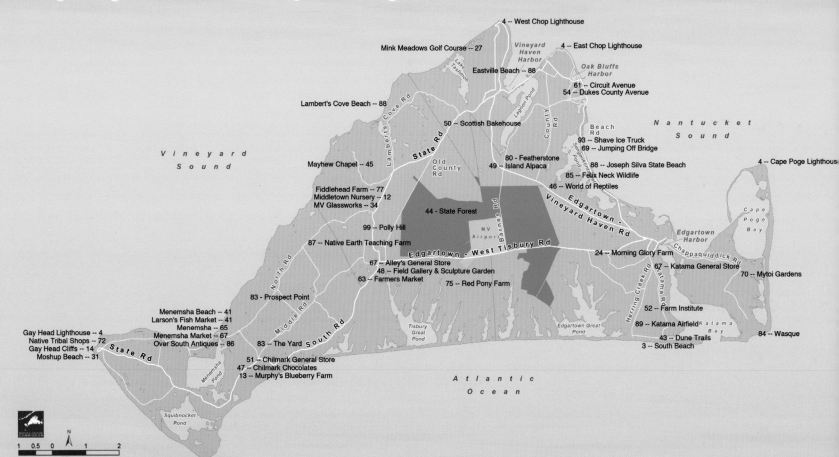

4 -- West Chop Lighthouse

Mink Meadows Golf Course -- 27

Vineyard Haven Harbor

4 -- East Chop Lighthouse

Oak Bluffs Harbor

Eastville Beach -- 88

61 -- Circuit Avenue
54 -- Dukes County Avenue

Lambert's Cove Beach -- 88

Lake Tashmoo

Lagoon Pond

County Rd

Beach Rd

Nantucket Sound

50 -- Scottish Bakehouse

93 -- Shave Ice Truck
69 -- Jumping Off Bridge

Vineyard Sound

Lambert's Cove Rd

State Rd

Old County Rd

80 - Featherstone
49 -- Island Alpaca

88 -- Joseph Silva State Beach

4 -- Cape Poge Lighthouse

Mayhew Chapel -- 45

85 -- Felix Neck Wildlife
46 -- World of Reptiles

Fiddlehead Farm -- 77
Middletown Nursery -- 12
MV Glassworks -- 34

44 - State Forest

MV Airport

Edgartown - Vineyard Haven Rd

Cape Poge Bay

Edgartown Harbor

99 - Polly Hill

87 -- Native Earth Teaching Farm

Dr Fisher Rd

Chappaquiddick Rd

24 -- Morning Glory Farm

Edgartown - West Tisbury Rd

67 -- Alley's General Store
48 -- Field Gallery & Sculpture Garden
63 -- Farmers Market

75 -- Red Pony Farm

67 -- Katama General Store

70 -- Mytoi Gardens

North Rd

83 - Prospect Point

Middle Rd

South Rd

Tisbury Great Pond

Herring Creek Rd

Katama Rd

52 -- Farm Institute

Menemsha Beach -- 41
Larson's Fish Market -- 41
Menemsha -- 65
Menemsha Market -- 67
Over South Antiques -- 86

Edgartown Great Pond

89 -- Katama Airfield

Katama Bay

84 -- Wasque

Gay Head Lighthouse -- 4
Native Tribal Shops -- 72
Gay Head Cliffs -- 14
Moshup Beach -- 31

State Rd

83 -- The Yard

43 -- Dune Trails
3 -- South Beach

51 -- Chilmark General Store
47 -- Chilmark Chocolates
13 -- Murphy's Blueberry Farm

Menemsha Pond

Atlantic Ocean

Squibnocket Pond

N

1 0.5 0 1 2
Miles

Eastville Beach -- 88

5 -- Grace Church

59 -- Vineyard Playhouse
19 -- Mocha Mott's Coffee Shop
95 - Steamship 58 -- Winds Up!
Black Dog General Store -- 100 86 -- Pyewacket's Antiques
25 - Black Dog Tavern & Tall Ships
17 -- Art Cliff Diner
79 -- Net Result Seafood

77 -- Tisbury Farm Market

90 -- Island Cove Mini-Golf

VINEYARD HAVEN

78 -- Al's Package Store

Fuller Street Beach -- 20
Harbor View Hotel -- 32

Edgartown Lighthouse -- 4

66 -- Atria
Edgartown Cinemas -- 40
Charlotte Inn -- 1 19 -- Espresso Love
Wharf Pub -- 29 64 -- Eisenhauer Art
Pagoda Tree -- 55 18 -- On Time Ferry
MV Museum -- 56 60 - Seafood Shanty
26 -- Mad Max

EDGARTOWN

4 -- East Chop Lighthouse

6 -- East Chop Drive

73 -- Book Den East

Dockside Marketplace -- 53 82 -- Lookout
7 -- Donovan's Reef
MV Sightseeing Bus -- 8
Sun 'n' Fun -- 39 11 -- Flying Horses
Camp Meeting Assoc. -- 15 36 -- Offshore Ale
Trinity Park Tabernacle -- 91 2 -- Ocean Park
Alison Shaw Art -- 54 37 - Back Door Donuts
Ryan Family Amusement - 94
98 - Ben & Bill's Ice Cream

Isabelle's Beach House -- 1
1 -- Tivoli Inn

OAK BLUFFS

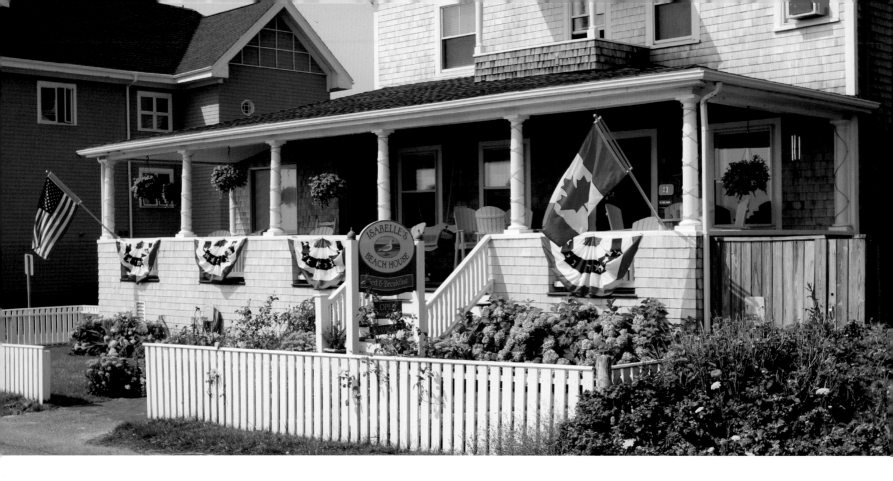

No. 1

Find a romantic bed and breakfast and spend the night

Isabelle's Beach House
83 Seaview Avenue, Oak Bluffs | www.isabellesbeachhouse.com

Isabelle's Beach House is a gem of a bed and breakfast, mixing a little New England charm with a little romantic ambience. And the location of the inn could not be better. It is directly across from the water and boasts spectacular panoramic ocean views from a large, sprawling front porch that's filled with plenty of rocking chairs. The rooms are airy and beach inspired, some with sunrise views in the morning. Just looking at her makes you want to kick off your shoes!

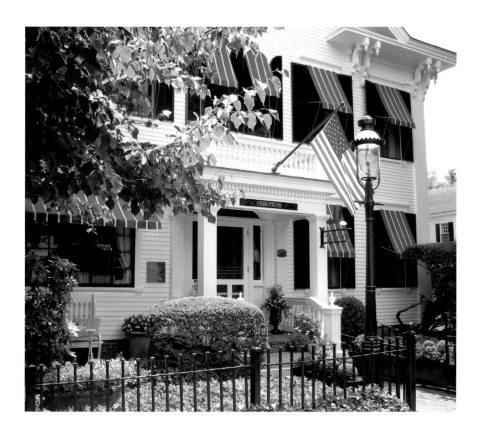

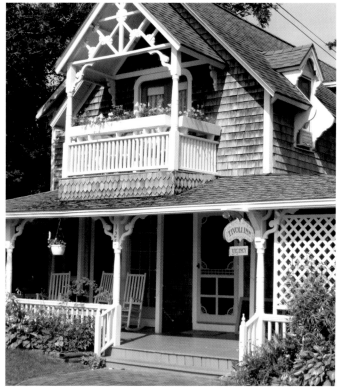

The Charlotte Inn
27 South Summer Street, Edgartown | www.thecharlotteinn.com

Quietly tucked away on South Summer Street in Edgartown, the grand Charlotte Inn is one of the island's finest and most well-known, upscale quality inns. The entire house is exquisitely appointed with fine art, elegant armchairs, and English antiques and the inn features artfully tended gardens, terrace dining, and charming, meandering ivy-edged brick walkways. The Charlotte Inn is truly a regal way to spend an evening . . . or a week.

Tivoli Inn
125 Circuit Avenue, Oak Bluffs | www.tivoliinn.com

A bit more "down home" is the lovely, cozy Tivoli Inn; romantically inspired in a charming Victorian gingerbread cottage. Just a few blocks from the main drag in Oak Bluffs, the flower-filled balcony and wrap-around latticed porch with rocking chairs makes this peaceful inn the ideal spot to spend the night. You just better hope they have a vacancy!

No. 2

Toss a Frisbee, fly a kite, or play ball on the huge great lawn known as Ocean Park

Ocean Park
Oak Bluffs

You might be coming to the island for the glorious beaches or the pristine nature preserves, but do not overlook this marvel of a good old-fashioned park right in the heart of Oak Bluffs. Flanked by some historic gingerbread cottages on one side and the blue ocean on the other, the park's centerpiece is a large white gazebo that serves as a bandstand for summer evening concerts. Run barefoot on the meticulously manicured grass, throw a Frisbee, practice yoga, fly a kite, or kick a ball; there's more than enough room to do whatever you please. Tip: Ocean Park is also a great spot to lie on a blanket and watch the evening stars.

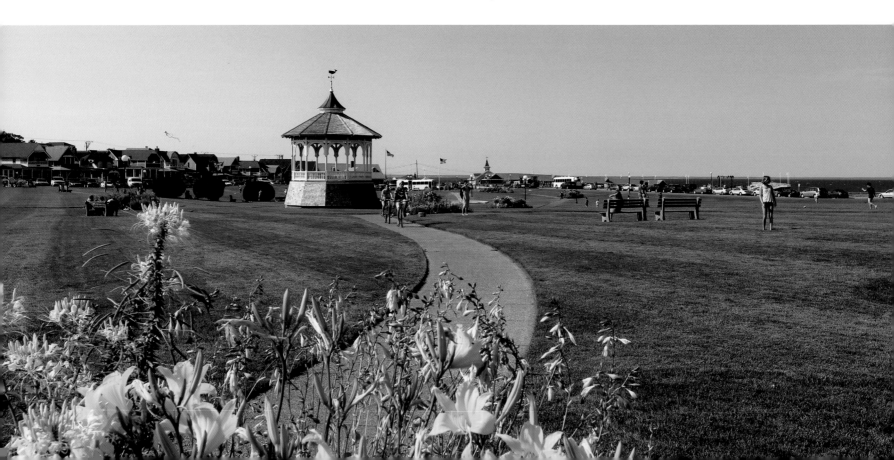

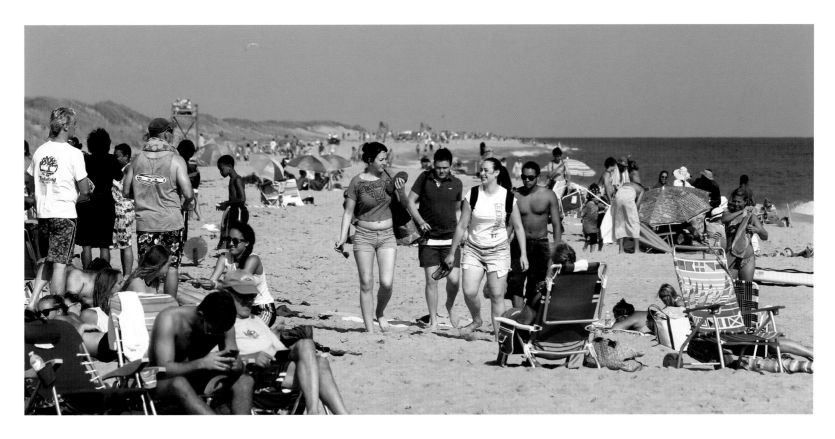

No. 3

Jump in the waves or just simply get a tan at South Beach, the island's most popular three-mile beach

Katama Beach, a.k.a. South Beach
Katama

Of all the beaches on the island, the three-mile stretch of sand known as South Beach is easily the most popular, especially with the younger set. Parking can be a challenge, but the vast expanse of soft sand and the heavy wave action make this beach a must-do. Tip: For peace and quiet, head to the middle area of the beach, as the crowds tend to pour in from both ends. Families are generally on the left end of the beach, college kids on the right.

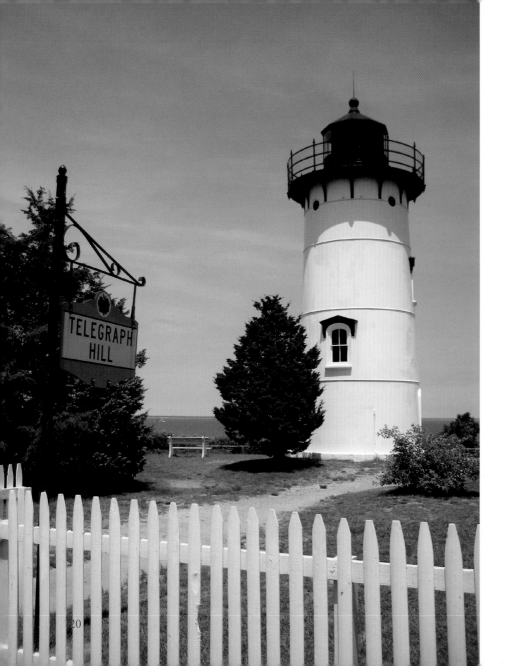

No. 4

Grab your camera, then try to photograph all five lighthouses on the island

East Chop Lighthouse
Telegraph Hill, 229 East Chop Drive, Oak Bluffs
www.mvmuseum.org

This historic cast-iron lighthouse was built in 1878 and stands majestically on a bluff known as Telegraph Hill along beautiful, scenic East Chop Drive. It overlooks the vast Vineyard Haven Harbor and Vineyard Sound in Oak Bluffs. The lighthouse is on the site of one of the first telegraph signal towers; signals were received from Nantucket and relayed on to Woods Hole and other towns. Tip: The Martha's Vineyard Museum conducts sunset tours here in the summer, so check ahead for meet-up times.

Edgartown Lighthouse
121 North Water Street, Edgartown
www.mvmuseum.org

Edgartown's quaint little lighthouse, the most accessible on the island, is just a short walk from the center of town at the end of North Water Street. The current cast-iron structure was built in 1881 and then renovated in 2007. The renovations included a staircase up to the lantern room, allowing for great views of Edgartown and, across the channel, Chappaquiddick Island. Tip: If you are getting married on the island, take the flower-lined path across from the Harbor View Hotel for a great photo op!

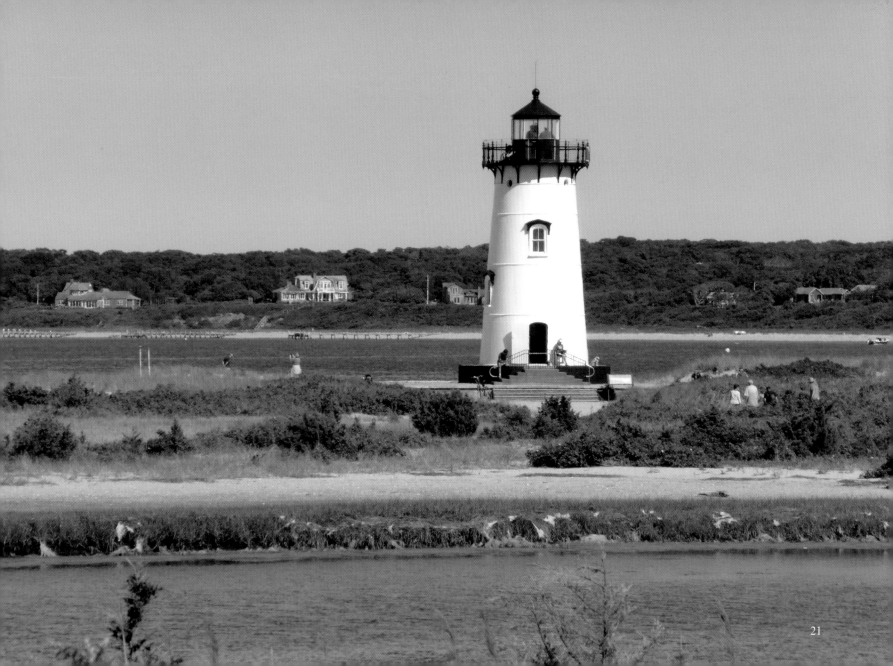

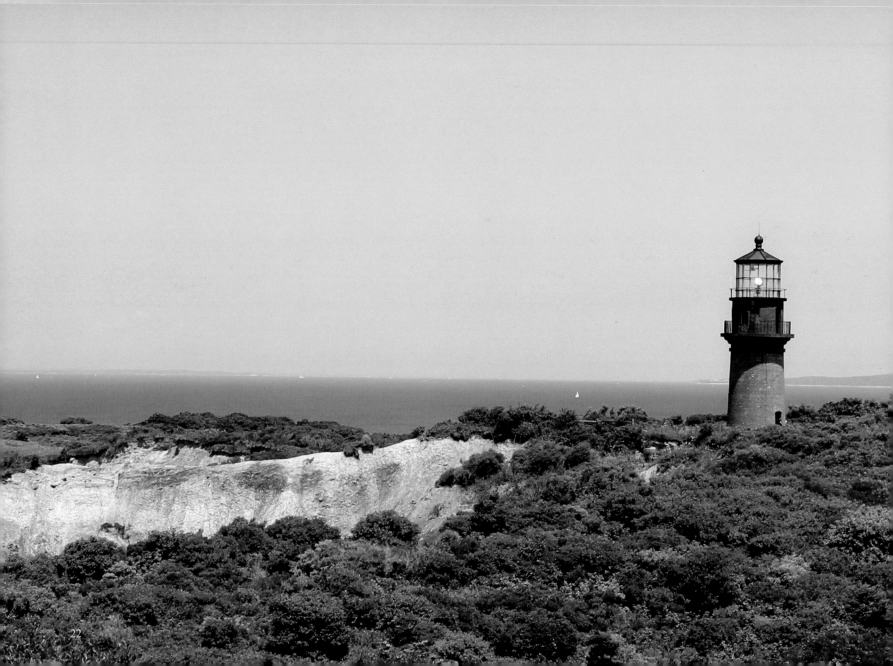

Gay Head Lighthouse
9 Aquinnah Circle, Aquinnah
www.mvmuseum.org

President John Adams commissioned the first
tower built here way back in 1799. It was originally
used to warn ships of the shoals known as the
Devil's Bridge, where 122 people drowned in a
shipwreck in 1884. The current red-brick
lighthouse was then constructed in 1856. It is
on the list of one of America's most endangered
historic places, as it stands just forty-six feet
from an eroding cliff. You can find the Gay Head
Light Up-Island in Aquinnah, perched on the
cliff's edge off Lighthouse Road.

West Chop Lighthouse
West Chop Road (Main Street), Tisbury
www.mvmuseum.org

Originally a wooden structure erected in 1817,
the lighthouse was rebuilt with brick in 1838
and moved back a bit from the bluff. It is located
at the entrance of the Vineyard Haven Harbor
on the northern tip of West Chop. Currently, the
tower is owned by the US Coast Guard and used
as a vacation house for military personnel. Sorry
to say, it is not open to the public, but there are
some good views from the road.

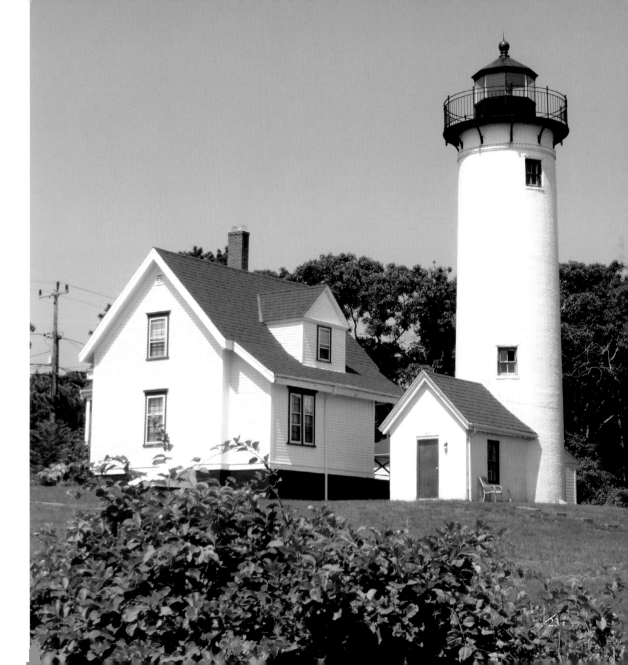

Cape Poge Lighthouse
Chappaquiddick Island
www.thetrustees.org

Of the five lighthouses, this wooden tower built in 1893 is definitely the most remote and hardest to reach. It's on the northeast tip of Chappaquiddick Island, and the only access is via the Trustees of Reservations Lighthouse Tour. You'll need to call for a reservation first. Then take the "On Time" ferry to Chappy, where a guide will pick you up. You'll transfer at Mytoi Gardens for a long and bumpy van ride over the sand dunes, where you'll finally find the Poge Lighthouse. You'll need to plan on several hours for this trip, but it is very scenic.

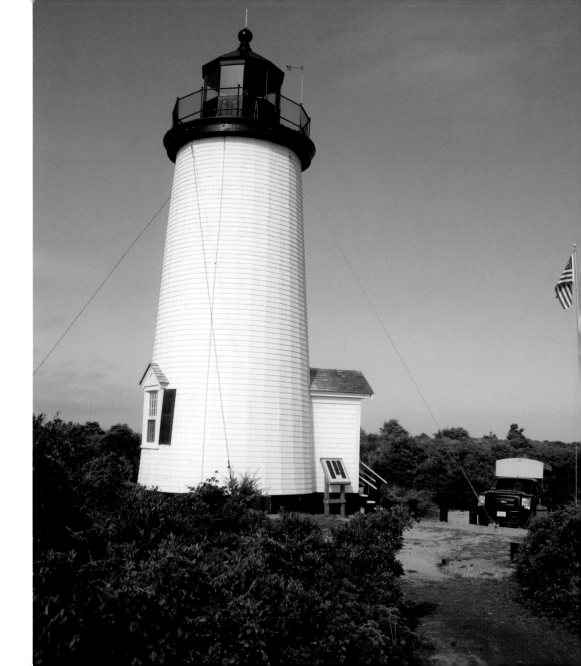

No. 5

Enjoy a generous lobster roll on Fridays at Grace Church in Vineyard Haven, a local favorite

Lobster Rolls at Grace Church
36 Woodlawn Avenue, Vineyard Haven | 508-693-0332

There are lots of places to get lobster rolls on the island, but none of them are quite like lobster rolls at Grace Church in Vineyard Haven. They've been offering these rolls every Friday night during the summer for almost thirty years, and this will be the best lobster roll you will ever have. Accompanied by a bag of chips and a beverage, the ladies serving the rolls seem delighted to see how high they can pile on the lobster meat. And it's not just tail meat, but lots and lots of sweet and tender claws and knuckles, with just a bit of mayo and white pepper to hold it all together. The sandwich is huge and delicious, the #1 bargain on the island! *Do not miss* Grace Church's lobster rolls from 4:30 to 7:30 on Friday evenings!

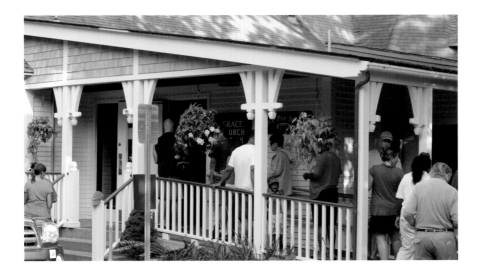

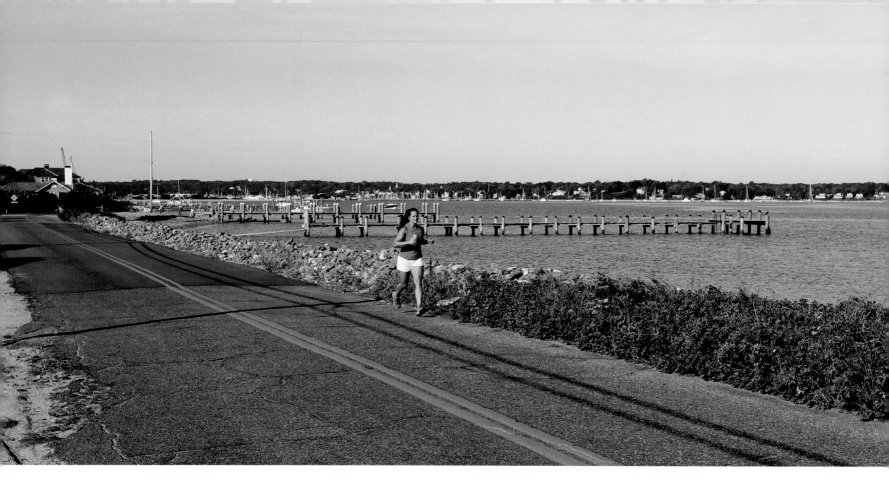

No. 6

Go for a jog along the ocean on East Chop Drive in Oak Bluffs

Jogging Along East Chop Drive
Oak Bluffs

I'm an avid jogger, and this stretch of road hugging the water is one of my favorite routes. With breathtaking views of Vineyard Haven Harbor and Nantucket Sound on one side and magnificent summer homes with manicured lawns on the other, it's very scenic, peaceful, and quiet. And having the opportunity to jog right past the East Chop Lighthouse is an added bonus.

No. 7

Order the famous Dirty Banana from Donovan at Donovan's Reef overlooking Oak Bluffs Harbor

Donovan's Reef
Outside Nancy's Oyster Bar, Oak Bluffs Harbor

If you like frozen drinks, then you are going to love Donovan's famous frozen Dirty Banana. Donovan has been here in this tiny shack in front of Nancy's Restaurant every summer since 2001, bartending seven nights a week throughout the summer season. In other words, he's always there! And thank God, because watching him as he prepares his many concoctions is half the fun. There is always a line, but when you finally reach Donovan, there's always a smile. Maybe that's because of his own personal "quality control" technique. You'll have to ask him about that!

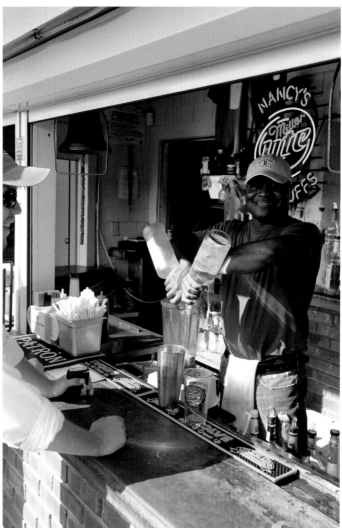

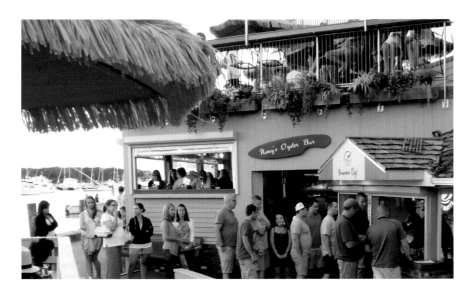

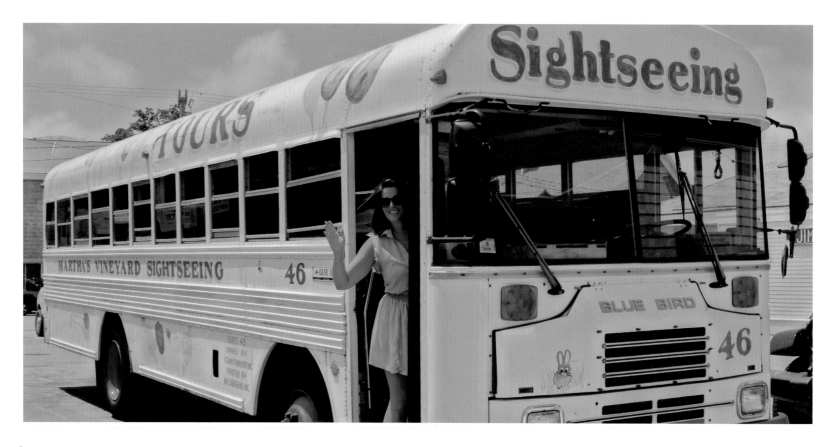

No. 8

Take a narrated tour of the island on the Martha's Vineyard Sightseeing Bus

Martha's Vineyard Sightseeing Tours
8 School Street, Oak Bluffs | 508-693-4681

If you are only visiting for a short period of time and want to get a quick look at the entire island, then the Martha's Vineyard Sightseeing Tour is for you. They offer a two-and-a-half-hour professionally narrated expedition through all six island towns, even allowing for a stop in Aquinnah to view the clay cliffs and shop for Wampanoag Tribe souvenirs. Their guides are well-versed in the landscape and local lore, so you might learn something even if you are a frequent visitor or even if you live here!

No. 9

Find a quiet, peaceful spot, and read a good book

Reading Refuge
Vineyard Haven

Reading a good book can transport you to another world, but reading a good book on Martha's Vineyard takes this relaxing pastime to another level. The island is loaded with serene little spots, even amongst the summer madness. Find yourself a quiet place, sink your feet into the sand, breathe the fresh ocean air and plunge into the pages of a new book.

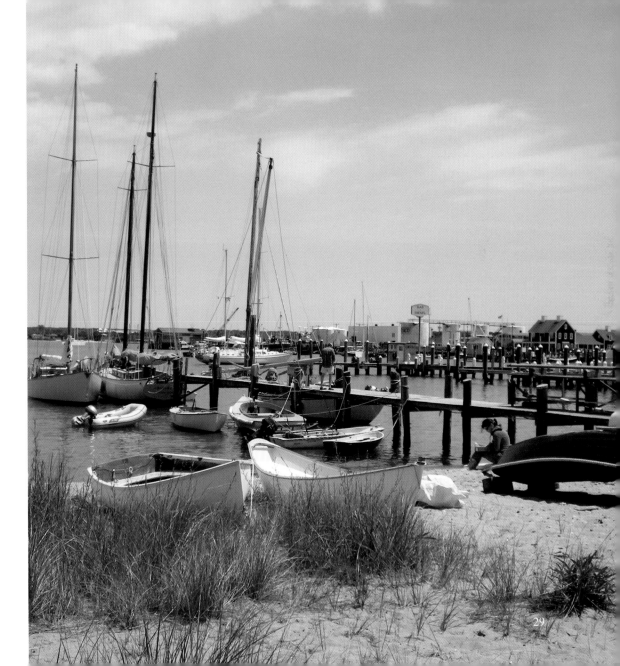

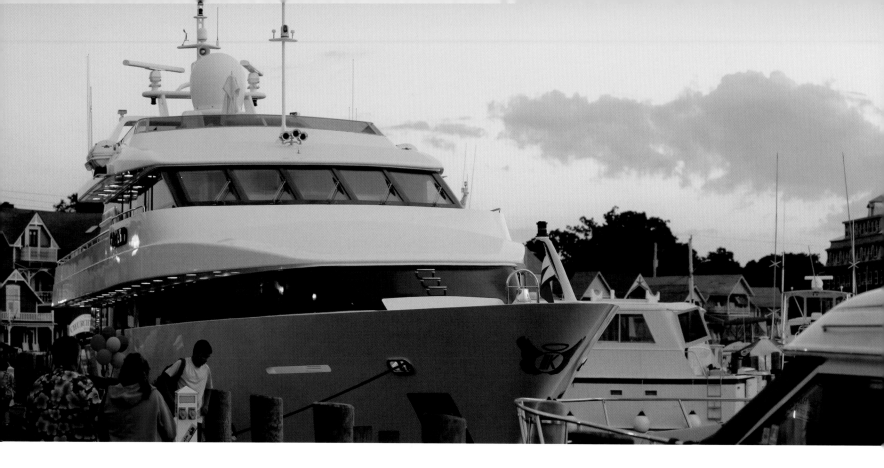

NO. 10

Stroll the harbors to check out all the huge, multi-million-dollar yachts docked on the water

Yacht-spotting
Oak Bluffs Harbor

Extravagant summer mansions go hand-in-hand with million-dollar yachts, so there is no shortage of these huge boats in any of the major harbors in Martha's Vineyard. While mere mortals are lining up for the ferry in Woods Hole, the rich and famous have the inside track to reaching the island on these luxuriously appointed, privately owned vessels. Ah, the good life!

No. 11

Ride the Flying Horses Carousel, and try to grab the brass ring

Flying Horses Carousel
15 Oak Bluffs Avenue, Oak Bluffs | 508-693-9481

Moved from Coney Island in 1884, the Flying Horses Carousel is the oldest operating platform carousel in America. The wooden horses were carved in New York City in 1876 and come complete with real horsehair tails! Try to catch the elusive brass ring to win a free ride. The Flying Horses are easy to find—just listen for that calliope music at the end of Circuit Avenue. Tip: If you are indeed lucky enough to grab a brass ring but choose not to take a free ride, please return the ring!

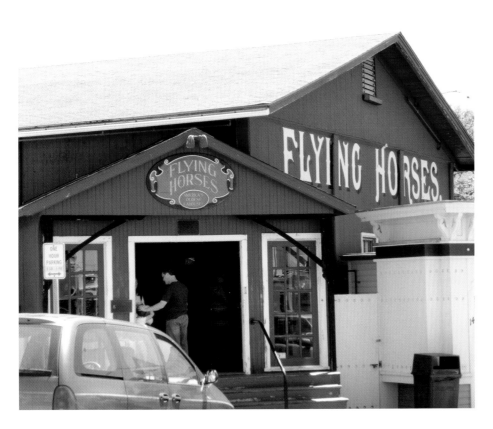

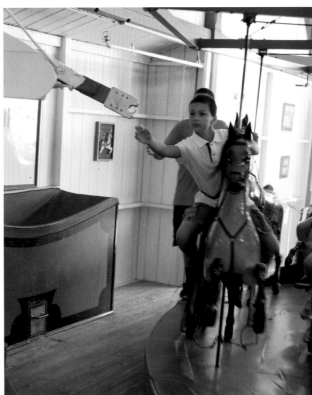

No. 12

Visit one of the many local nurseries and plant something

Middletown Nursery
680 State Road, West Tisbury | www.middletownnursery.com

Plants and flowers always make people happy. They are sunshine. Their fragrance and incredible colors are an inspiration. So do yourself and your soul some good by wandering around in one of the many fine nurseries on the island. I know you'll find something beautiful. Take it home, and plant it!

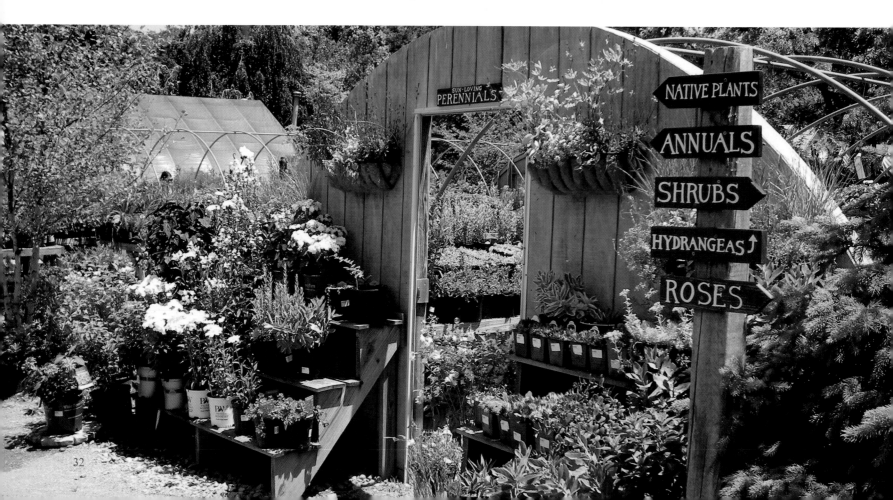

No. 13

Make an appointment to pick your own blueberries at Murphy's Blueberry Farm in Chilmark

Murphy's Blueberry Farm
8 Rumpus Ridge Road, Chilmark | 508-645-2883

Tucked away at the far end of Chilmark, up Rumpus Ridge Road, is where you find Susan & Lynn Murphy's Blueberry Farm. They've planted over 400 bushes, and in the summer months you can wander around and pick your own berries. And I've got to tell you, fresh picked berries right off the branch are delicious! Unfortunately, weather doesn't always cooperate, so the berries might not arrive. Tip: Picking blueberries is by appointment only, so you will need to call ahead to make arrangements.

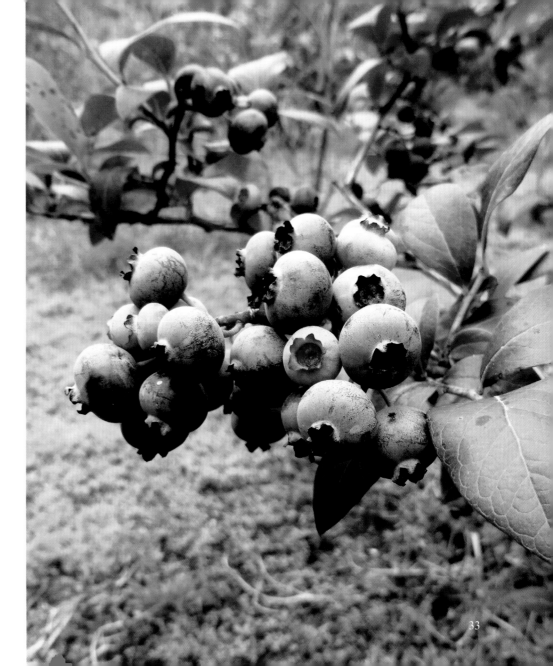

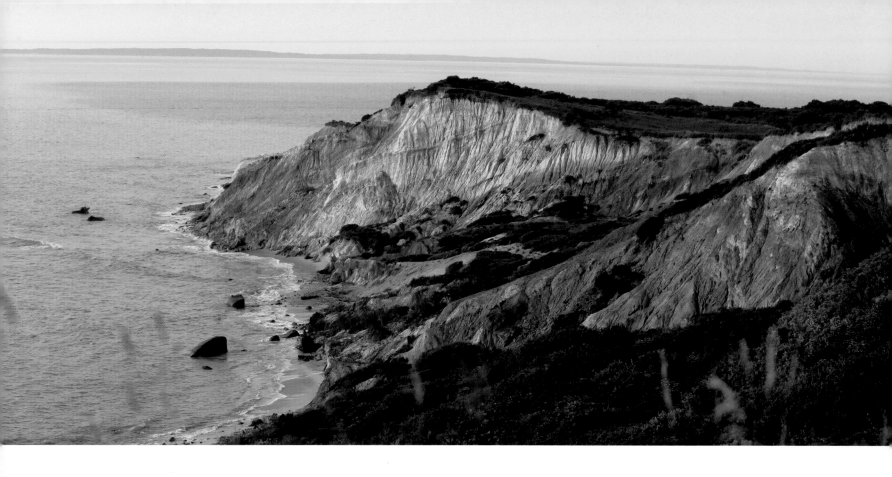

No. 14

Hike the scenic clay cliffs of Aquinnah, a.k.a. Gay Head Cliffs

Clay Cliffs of Aquinnah
Aquinnah

These epic, brilliantly colored clay cliffs are one of the island's major attractions, and rightfully so. They were formed millions of years ago by glaciers and are now part of the Wampanoag Reservation and under special environmental protections to deter erosion. They are located on the western-most part of the island, making it a long trek out there—about an hour on the bus from Oak Bluffs—but it is time well spent. Tip: Walk down to the beach parking lot, then take the worn path that leads down to the beach where you will be rewarded with spectacular (and the best!) views of the towering clay cliffs from sea level.

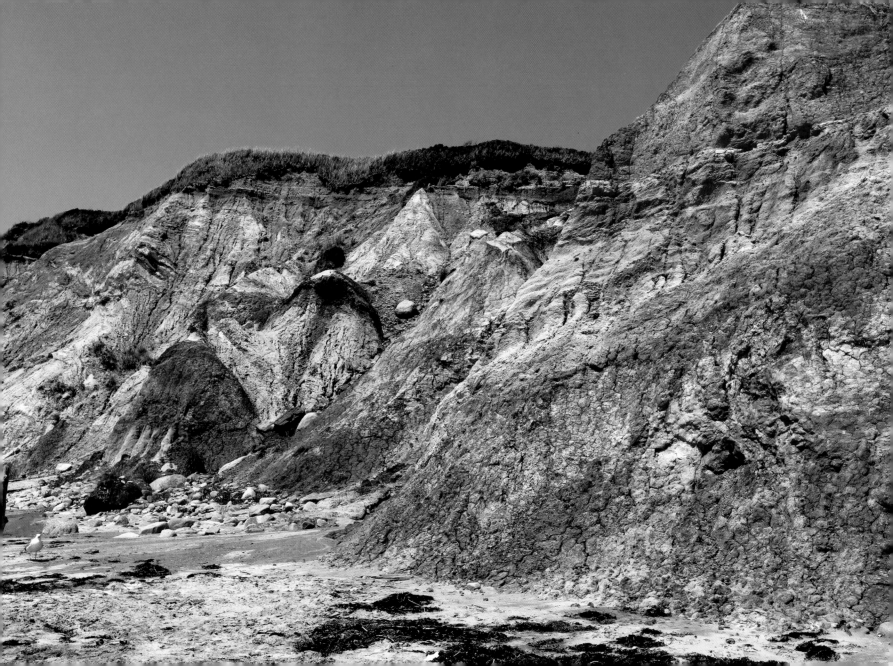

No. 15

Walk through the colorful village known as "the campground" with more than 300 ornate, tiny gingerbread cottages

The Martha's Vineyard Camp Meeting Association
Oak Bluffs | www.mvcma.org

What started out as a gathering of Methodists camping in tents for church revival meetings in the early nineteenth century has today turned into an unbelievable fairy-tale-like village nestled around the huge tabernacle in Wesleyan Park. More than 300 ornate gingerbread cottages, mostly built in the late nineteenth century and painted in bright colors and pastels, line the narrow winding streets of this historic "campground." Be sure to take a walking tour of this amazing village when you visit the island. Tip: There's a wonderful little cottage museum in the far corner of the campground. It's really neat, so check it out.

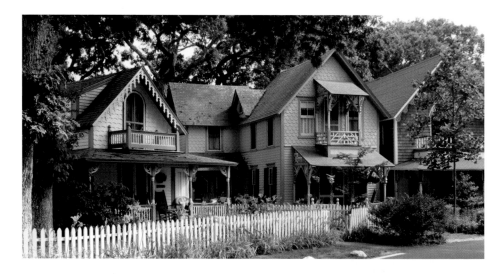

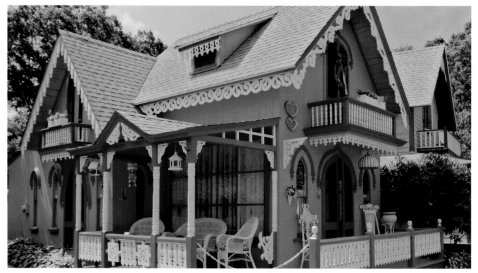

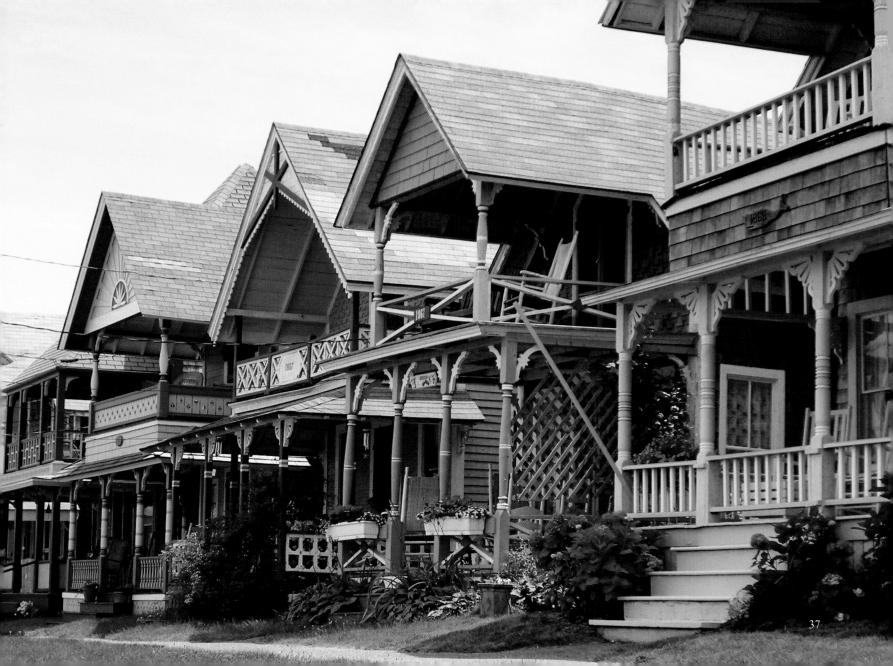

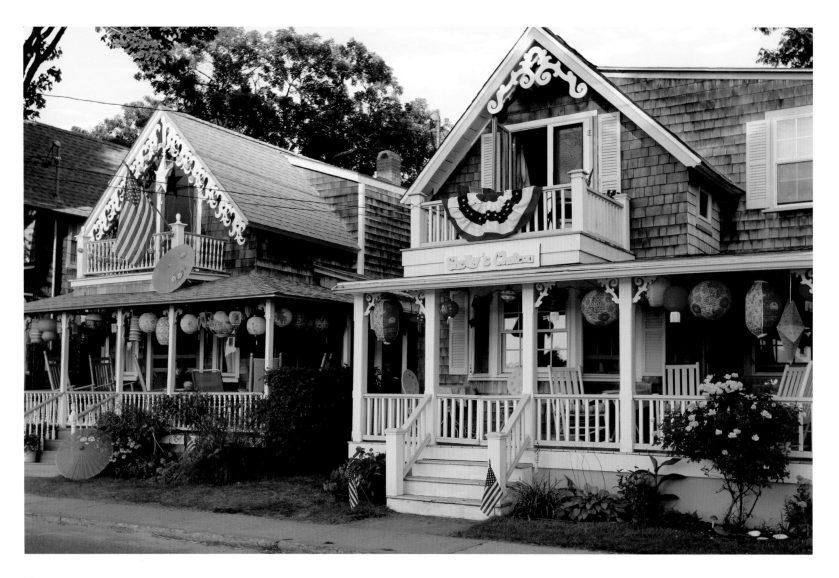

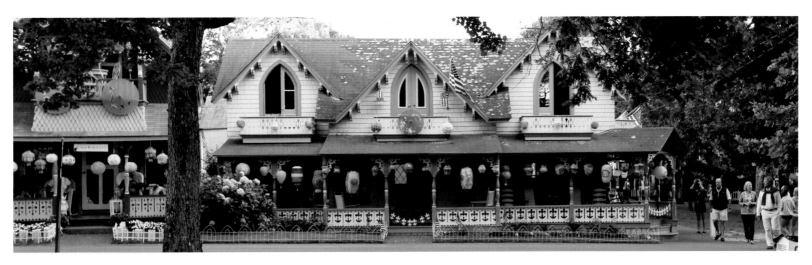

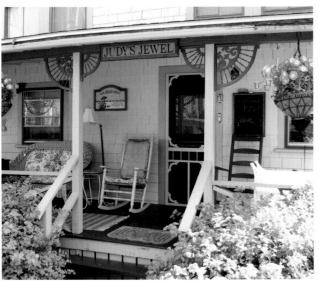

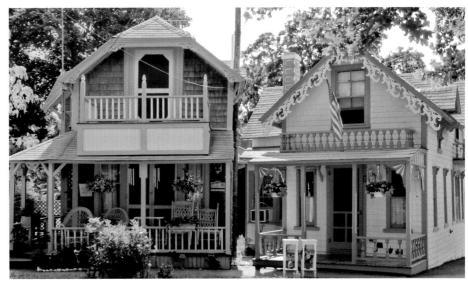

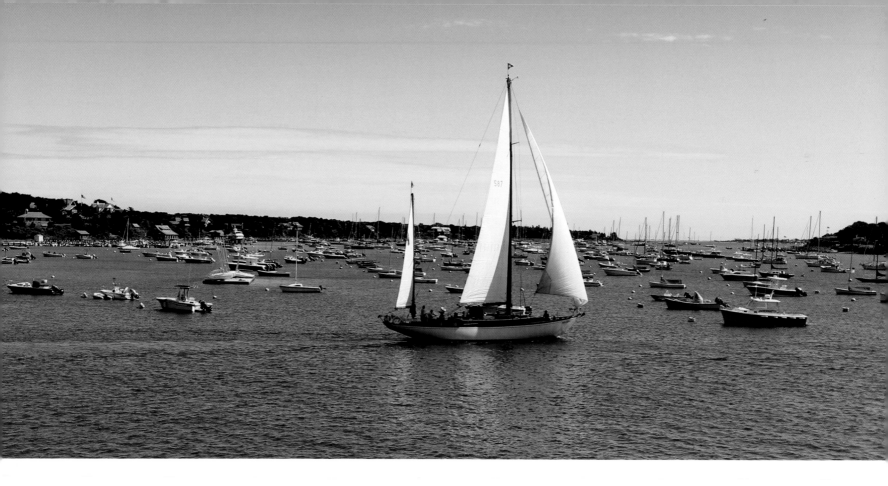

No. 16

Admire the boats in Edgartown Harbor, one of the most beautiful harbors in the world

Edgartown Harbor
Edgartown

From early spring to late fall, Edgartown Harbor bustles with sailboats and some of the most glitzy multi-million-dollar yachts imaginable. This picturesque harbor faces Chappaquiddick with bewitching views in every direction and is considered by many to be one of the most beautiful harbors in the world. Tip: There's a wonderful lofted viewing deck slightly hidden right next to the Chappy ferry. The views are great!

No. 17

Get a good old-fashioned breakfast at the Art Cliff Diner, another local favorite

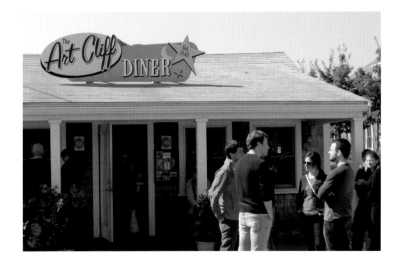

Art Cliff Diner
39 Beach Road, Vineyard Haven | 508-693-1224

If you want good food, always ask a local. And if you ask any local about breakfast on the island, you will likely get the same response, the Art Cliff Diner. On any given morning, the dining room is a beehive of happy diners. The room smells of fresh coffee, bacon and eggs, freshly cooked pancakes, frittatas, and fruit crepes. You really need to try the Drunken Sailor Pancakes! And don't worry about the wait for a table, as the line moves fast. Tip: Go early because the room fills fast, Also, the diner is closed on Wednesdays and closes at 2:00 p.m. on other days.

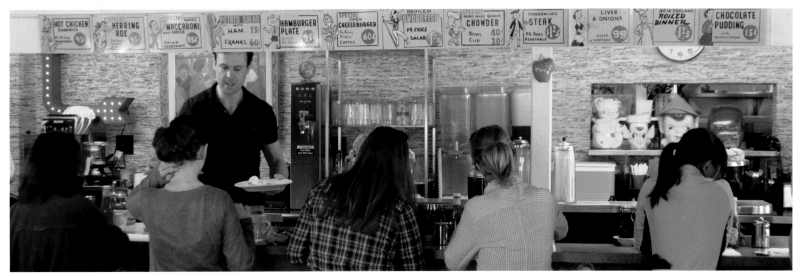

No. 18

Take the old three-car "On Time" ferry to Chappaquiddick, and drive around Chappy trying to spot the Kennedys!

"On Time" Ferry
Edgartown to Chappaquiddick

The "big island" of Martha's Vineyard is separated by the "little island" of Chappaquiddick by only 527 feet, but other than your own personal craft, the only access to Chappy is by two tiny ferries that crisscross midway through the channel. Weaving and bobbing amongst the water's other traffic, the twin ferries carry foot passengers, bicycles, and up to as many as three cars across the harbor every few minutes. And since they have no set schedule, they are always "On Time"!

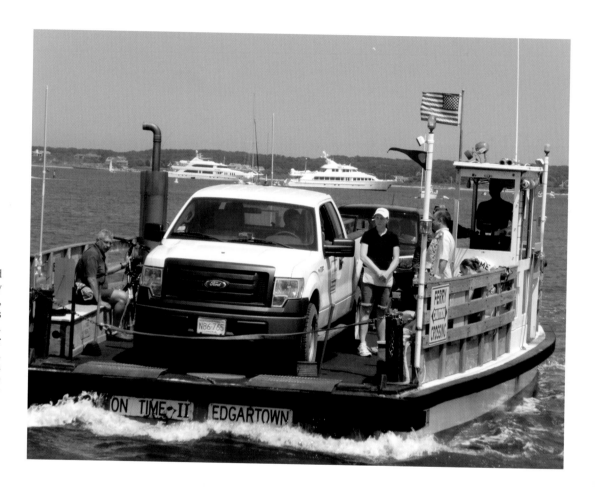

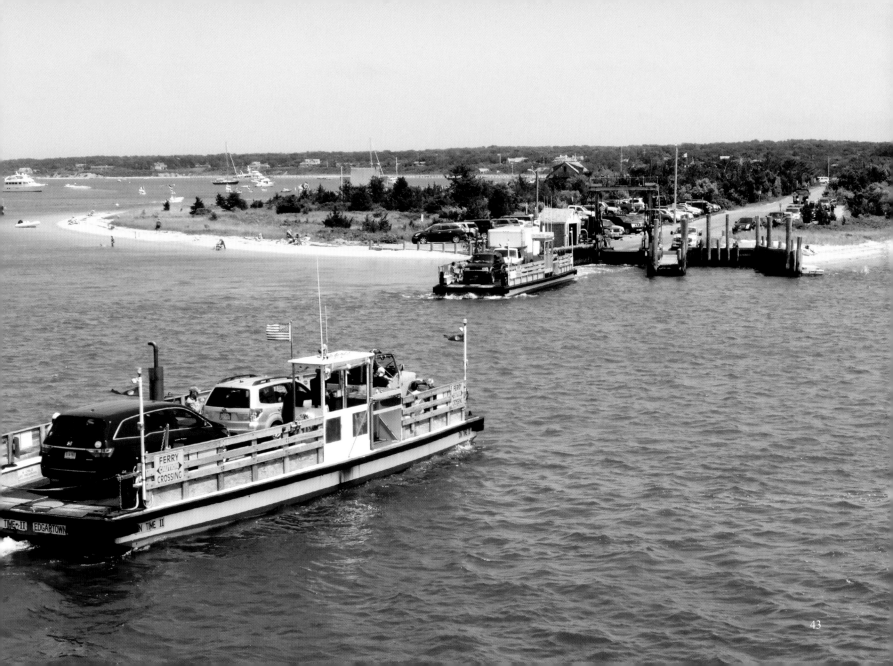

No. 19

Get a great cup of coffee at either Espresso Love or Mocha Mott's coffee shops

Mocha Mott's
15 Main Street, Vineyard Haven
www.mochamotts.com

A cool little coffee shop located right on Main Street in Vineyard Haven, Mocha Mott's can probably be best described as an eclectic hipster hangout with an organic flare. The menu is fairly limited, but they do have some nice breakfast goodies along with some darn good burritos. They also have a second location on Circuit Avenue in Oak Bluffs.

Espresso Love
17 Church Street, Edgartown
www.espressolove.com

If you're in Edgartown and you love espresso, then this is your place. They're kinda hidden off the parking lot behind the courthouse, which might explain why this great little coffee shop always seems to have a local vibe to it. It also helps that they offer lots of yummy pastries, fancy bagels, and great sandwiches.

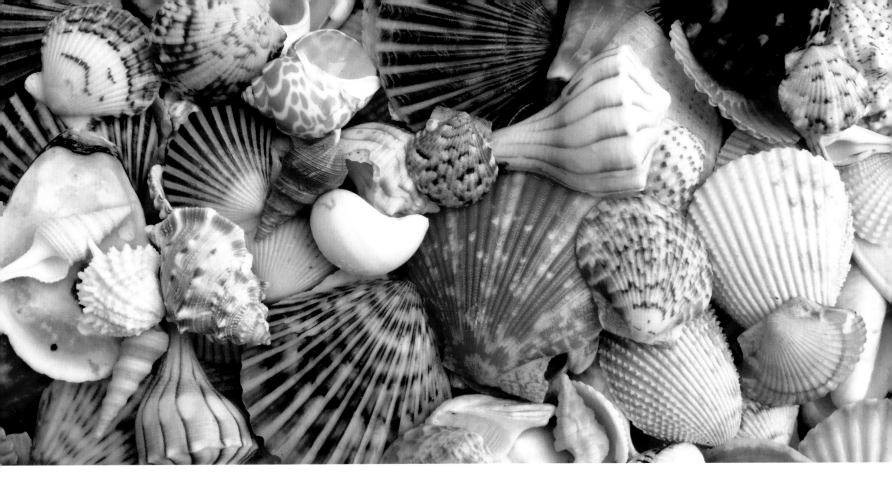

No. 20

Collect some exotic seashells from the secluded beach at the end of Fuller Street

Seashells from the Fuller Street Beach
End of Fuller Street, Edgartown

Everyone loves to collect a few brightly colored seashells to take home as a memento, but sometimes finding them is a little problematic. A great little spot for searching out shells is the Fuller Street Beach, where scallop shells are always in great abundance. And the site comes complete with a great view of the Edgartown Lighthouse. Tip: Go early in the morning for the best pickin's.

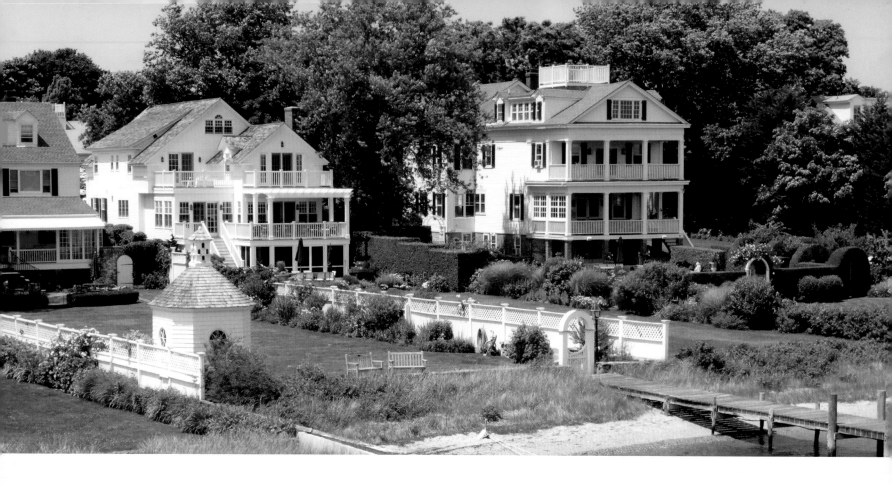

No. 21

Take a walking tour of the old dignified whaling captains' mansions along the harbor in Edgartown

Mansions overlooking Edgartown Harbor
Edgartown

During the 1880s, Edgartown was a prime port for whaling vessels, and many of the successful whaling captains stayed and built these stately, white-clapboard homes facing Edgartown Harbor. Hundreds of these Federal-style mansions, complete with adorning white picket fences, line both sides of many of the streets in town. Take a walk down North or South Water streets to see the best selection of these immaculately kept grand structures.

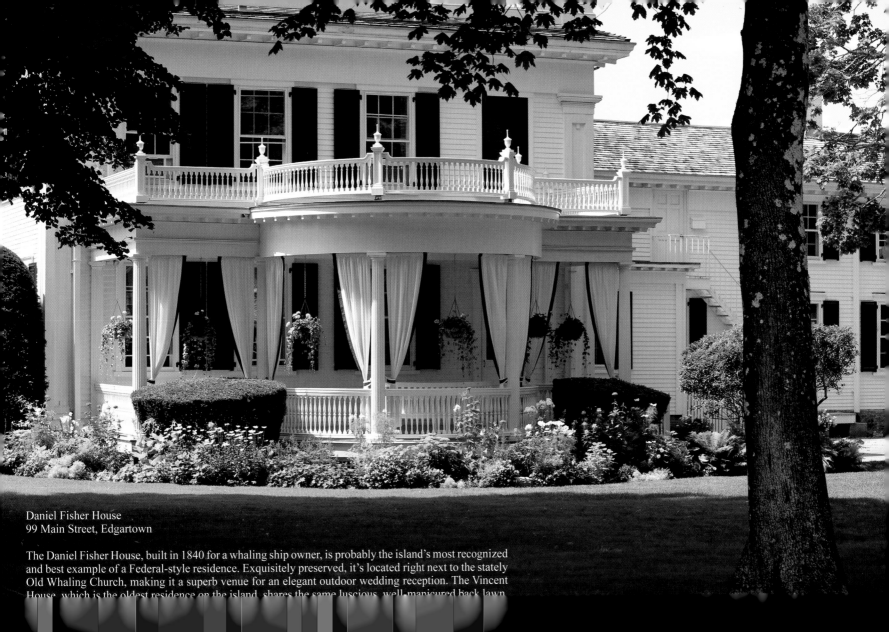

Daniel Fisher House
99 Main Street, Edgartown

The Daniel Fisher House, built in 1840 for a whaling ship owner, is probably the island's most recognized and best example of a Federal-style residence. Exquisitely preserved, it's located right next to the stately Old Whaling Church, making it a superb venue for an elegant outdoor wedding reception. The Vincent House, which is the oldest residence on the island, shares the same luscious, well-manicured back lawn

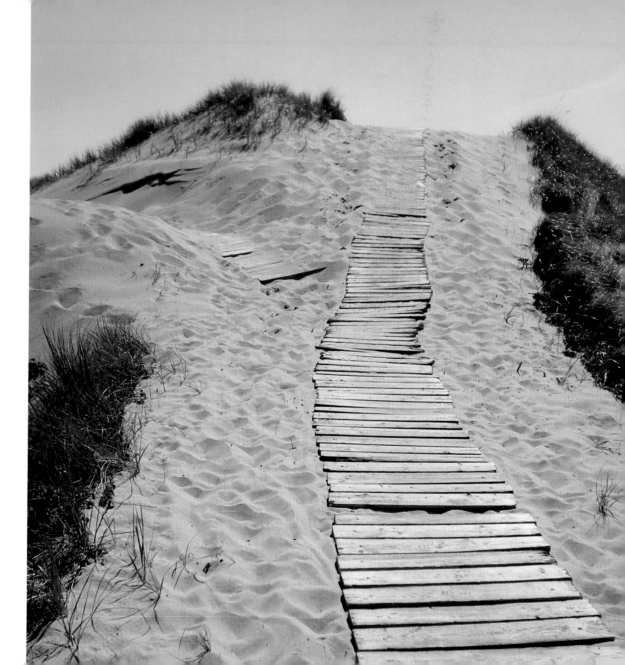

No. 22

Follow a rickety path along the dunes

A Rickety Path
South Beach, Katama

The sun gets very hot in the summer, so thank god for these wonderful wooden planks that lead us to the beach and the Atlantic Ocean. Winding over the dunes, they're meant to be helpful, but the worn look is just so precious. Follow a rickety path, no telling where it might lead!

No. 23

Enjoy some fresh seafood and a refreshing ocean breeze at a waterfront open-air raw bar

Coop de Ville
Dockside Marketplace, Oak Bluffs
www.coopdevillemv.com

C'mon, you're surrounded by ocean! What a great chance to sample some of the freshest seafood you'll ever find. Raw bars are easy to stumble upon here on the island, and they're loaded with littlenecks, shrimps, oysters, and lobsters. For a nice breakfast treat, try a freshly shucked oyster topped with a little Bloody Mary mix and a shot of vodka. A great no-frills raw bar spot is *Coop de Ville* on the harbor. It's also a perfect spot to watch the boats and take in a soccer game on the tube.

No. 24

Create your own freshly picked garden salad from the salad bar at the Morning Glory Farm

Morning Glory Farm
120 Meshackett Road off West Tisbury Road, Edgartown
www.morninggloryfarm.com

Although advertised as a roadside stand, this fantastic farm facility is so much more. The main store is housed in a large rustic barn-like building, surrounded by sixty acres of farmland brimming with vegetables and small fruits. Stop for sweet corn, green beans, carrots, potatoes, homemade pies, and breads, but don't leave without making your own salad from the freshly picked garden salad bar. If you are looking for the best quick, inexpensive, healthy lunch on the island, look no further than the Morning Glory Farm salad bar!

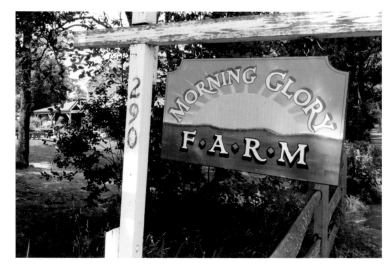

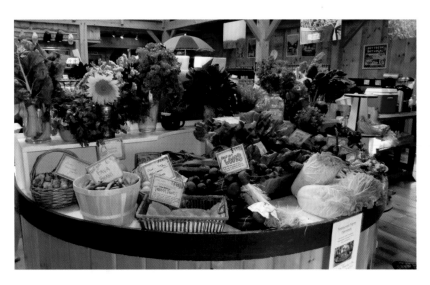

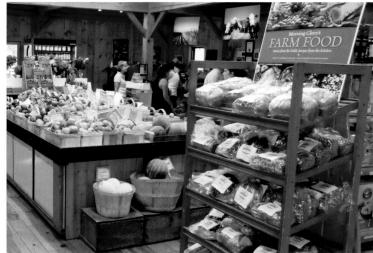

No. 25

Grab a bite to eat at the original Black Dog Tavern in Vineyard Haven

Black Dog Tavern
21 Beach Street EXT, Vineyard Haven
www.theblackdog.com

The Black Dog Tavern started right here in 1971. It was opened on New Year's Day by Captain Robert Douglas, who recognized a lack of good food available in the winter months. Originally established with shared recipes for pies, chowders, and soups, their stores and cafes have since expanded all over the northeast and their famous Black Dog logo is known around the world. Tip: Go around back to find a delightful outdoor patio!

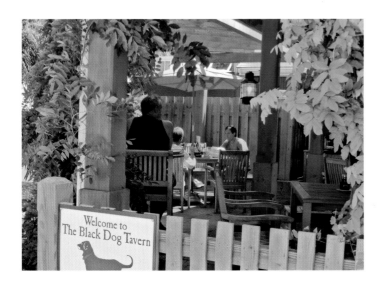

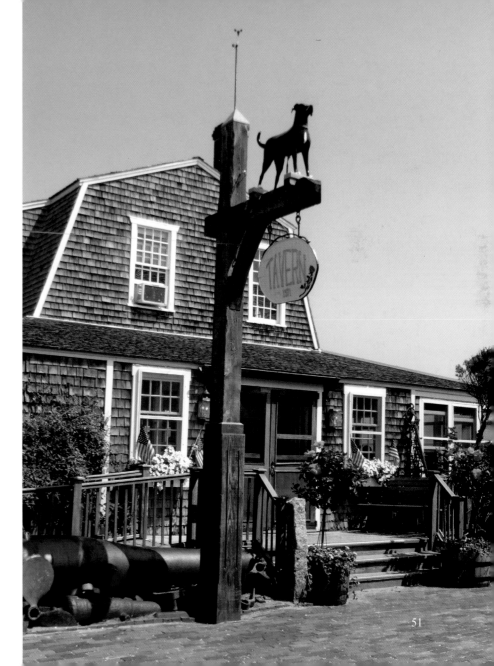

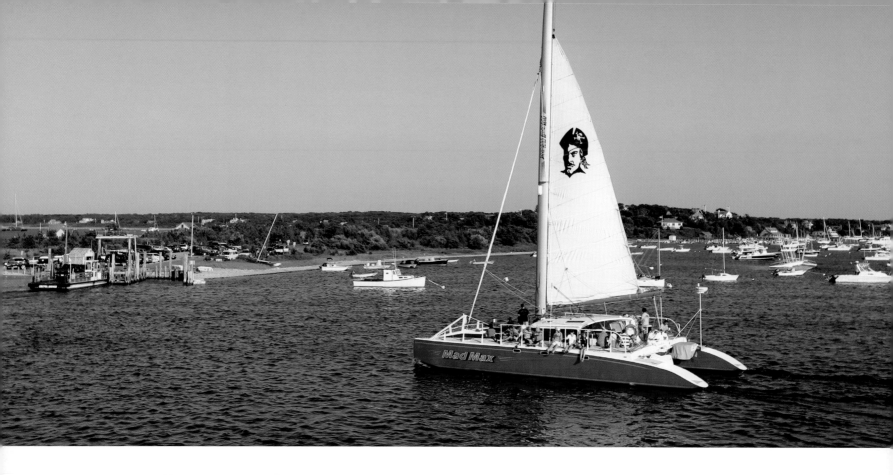

No. 26

Go for a sunset sail on the ocean aboard the Mad Max catamaran or the Black Dog Tall Ships

Mad Max Catamaran
25 Dock Street, Edgartown Harbor | ww.madmaxmarina.com

Sit back, sip on a cool beverage, and pretend you are one of the Kennedys aboard this beautiful sixty-foot, twin-hull catamaran. Departing right behind the Seafood Shanty on historic Edgartown Harbor, this state-of-the-art sailing vessel glides past the grand whaling ship captains' mansions, the Edgartown Lighthouse, and Chappaquiddick Island. The sunset sail departs at 6 PM daily. Tip: It's B.Y.O.B., so grab yourself a little something to drink before you board.

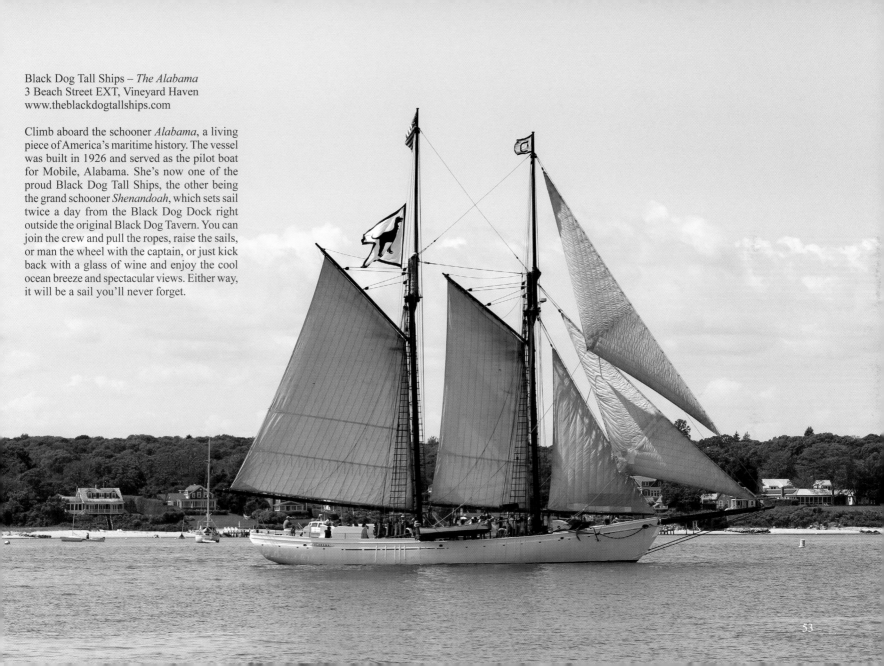

Black Dog Tall Ships – *The Alabama*
3 Beach Street EXT, Vineyard Haven
www.theblackdogtallships.com

Climb aboard the schooner *Alabama*, a living piece of America's maritime history. The vessel was built in 1926 and served as the pilot boat for Mobile, Alabama. She's now one of the proud Black Dog Tall Ships, the other being the grand schooner *Shenandoah*, which sets sail twice a day from the Black Dog Dock right outside the original Black Dog Tavern. You can join the crew and pull the ropes, raise the sails, or man the wheel with the captain, or just kick back with a glass of wine and enjoy the cool ocean breeze and spectacular views. Either way, it will be a sail you'll never forget.

No. 27

Play eighteen holes of golf at Mink Meadows in Vineyard Haven

Mink Meadows Golf Club
320 Golf Club Road, Vineyard Haven | www.minkmeadowsgc.com

If you are planning to visit Martha's Vineyard, don't forget to bring your sticks! This meticulously maintained semi-private course is a great way to spend an afternoon. Located close to the tip of West Chop, the rolling terrain and magnificent ocean vistas over Vineyard Sound make Mink Meadows a must-do. The panoramic views overlooking the ocean from the eighth hole alone are reason enough to play the course. Tip: Non-members can make tee times two days in advance.

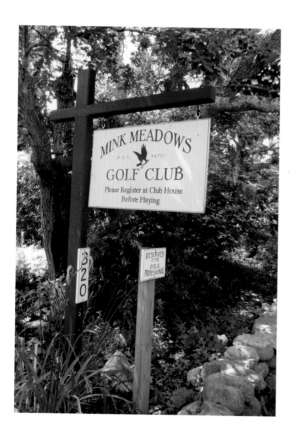

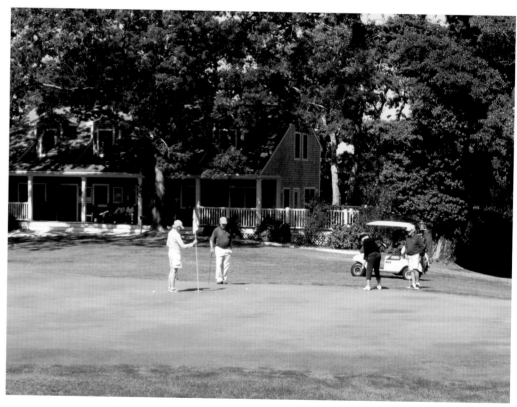

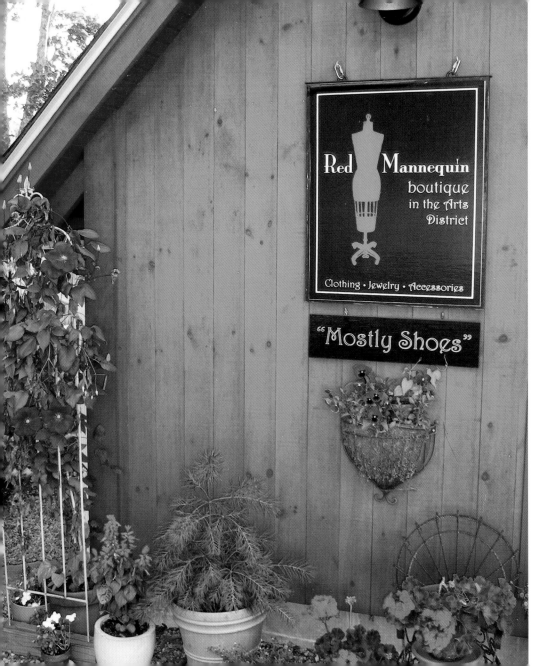

No. 28

Shop for shoes . . . mostly shoes!

Red Mannequin Boutique
93 Dukes County Avenue, Oak Bluffs

Shopping is, of course, always a big "thing to do" when visiting. If you spend time searching you can find some wonderful personal treasures all throughout the island. Stylish items like gemstone jewelry, loose-knit scarves, and leather hand totes can be found at the Red Mannequin, but it's the shoes, mostly shoes, that will attract you to this boutique. For some reason it was this shop in particular that called out to me as I drove by. That cute little sign "Mostly Shoes" gave me the idea for this book!

No. 29

Hang out with the locals, and drink beer at The Wharf Pub in Edgartown

The Wharf Restaurant & Pub
3 Main Street, Edgartown | www.wharfpub.com

If you're the type that likes dimly lit bars and rubbing elbows with the locals, this is your kind of place. The Wharf is a gem of a cozy hangout, complete with plenty of draft beer, bar fare, and sports TV. It's the best and most popular place on the island to watch Red Sox games. The adjoining restaurant is known for their tasty chowder and local seafood.

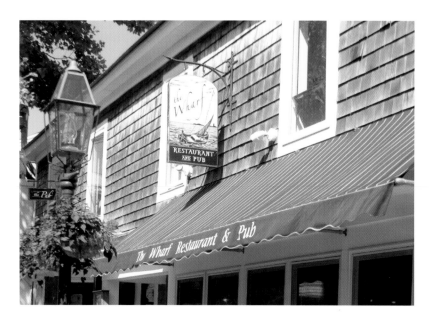

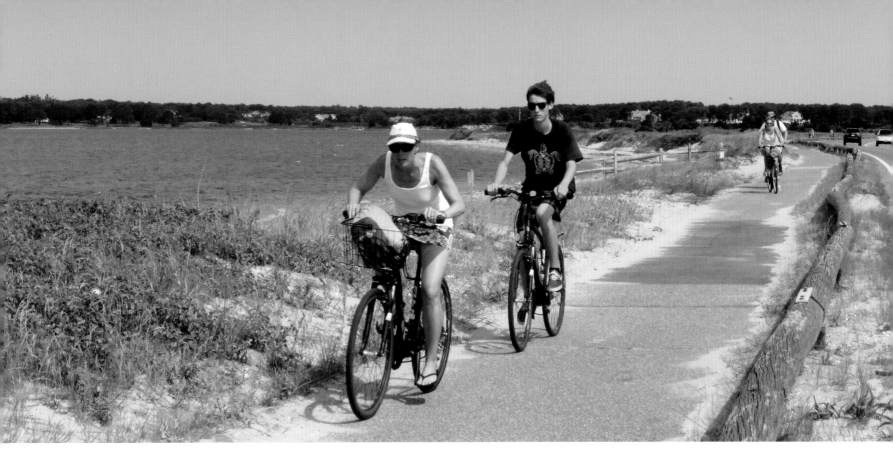

No. 30

Rent a bike in Oak Bluffs, and ride the six-mile bike path along the ocean to Edgartown

Riders on the Bike Path
Oak Bluffs to Edgartown along Beach Road

The most popular bike ride on the island is this winding six-mile path the leads from Oak Bluffs to Edgartown. There are sweeping ocean views on one side and lush marshlands surrounding Sengekontacket Pond on the other. It's a very scenic ride, but you'll be sharing the path with walkers, runners, and inline skaters, so use caution and keep your eyes on the road. Tip: So as not to backtrack on your return trip, take Edgartown-Vineyard Haven Road to County Road to Wing Road up to Oak Bluffs. It's inland, so it's not as scenic and not as crowded, but it makes for a nice change of pace.

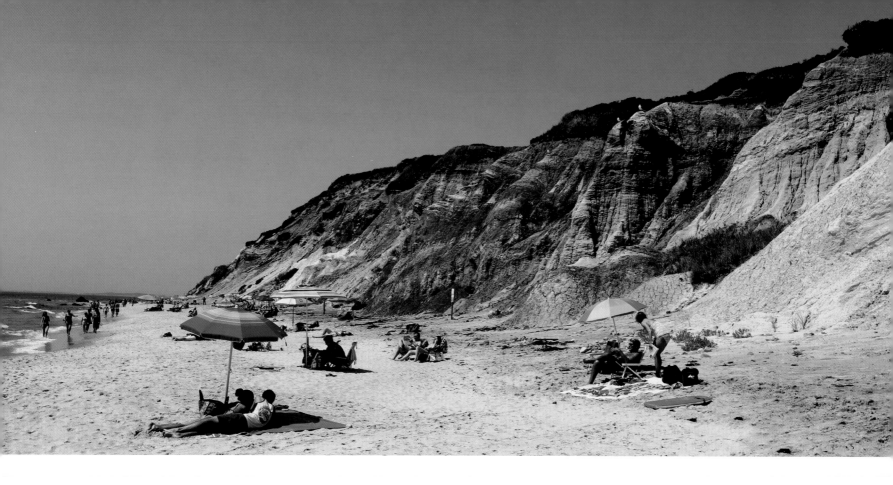

No. 31

Hike down the cliffs,
and enjoy a beautiful day on
Moshup Beach in Aquinnah

Moshup Beach
Aquinnah

Aquinnah's public beach off Moshup Trail is one of the best-kept secrets on the island. Because it is not well known and a bit hard to reach, it is generally not very crowded. The soft white sand and beautiful views of the spectacular Gay Head Cliffs make it one of the better ways to spend the day in the sun. The only drawback: parking is fifteen dollars a day.

No. 32

Grab a glass of wine or a martini and sit on a rocking chair admiring the harbor at the posh Harbor View Hotel

Harbor View Hotel and Resort
131 North Water Street, Edgartown | www.harbor-view.com

The grande dame of all hotels on the island is the popular Harbor View Hotel. If you're spending a lot of time running around seeing the sights and need some downtime, this is your spot! Away from the hustle and bustle in the center of Edgartown and just a few minutes stroll down scenic North Water Street is where you'll find this majestic 114-room structure overlooking the harbor. Priceless views of the boats, the lighthouse, the grass-swept beach, and Chappaquiddick Island can be had from the spacious veranda filled with rocking chairs. Tip: There's a jazzy little bar inside the hotel just off the restaurant. Order yourself a nice glass of wine or a martini, then meander out to the porch and enjoy the views!

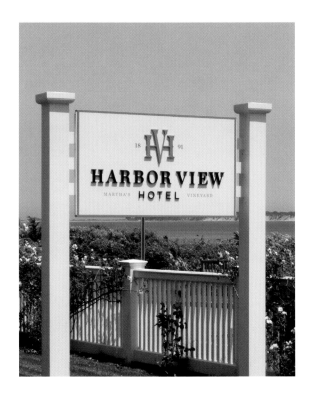

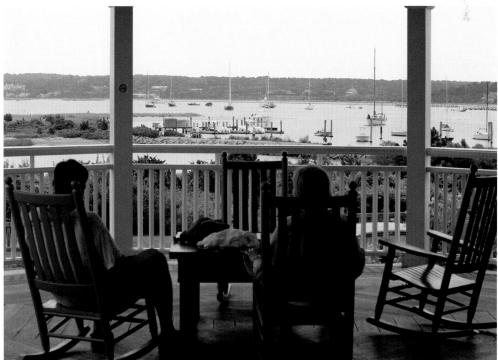

No. 33

Collect some beautiful multicolored stones along the beach in Menemsha

Collection of Beach Stones
Menemsha

Evocatively patterned, shaped, and multihued, beach stones are a delight to find. And the best spot for collecting these colorful stones is right on Menemsha Beach. Walking along the water's edge, the waves' ebb and flow reveals orange, red, brown, green . . . every color imaginable. Your eyes can get transfixed on the simmering stones. And they're free for the taking! Tip: When standing on the main beach, head to the right over the rock jetty for the best selections.

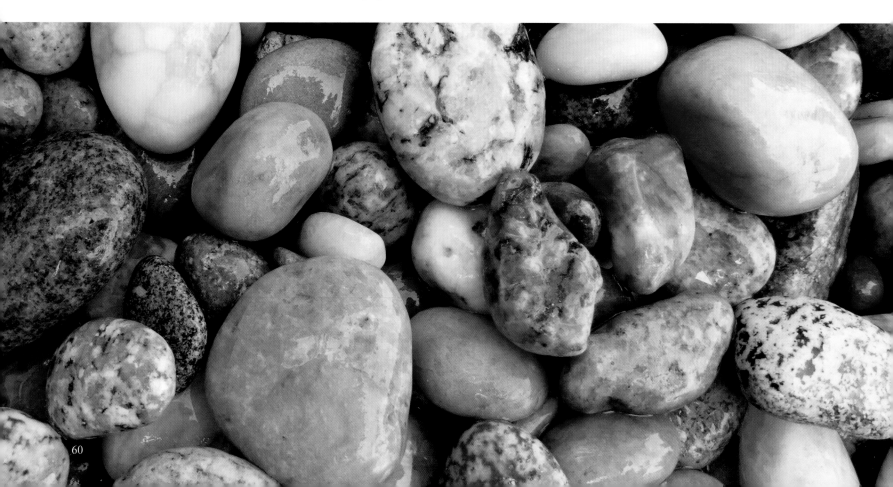

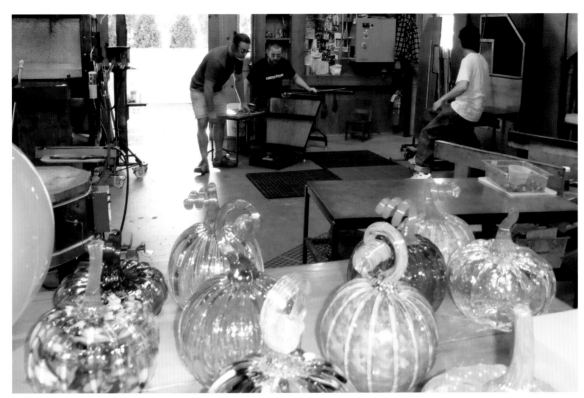
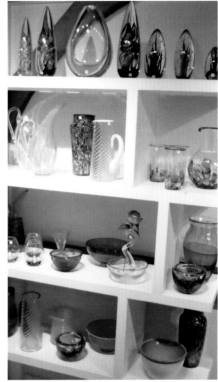

NO. 34

Watch glass blowing at Martha's Vineyard Glassworks in West Tisbury

Martha's Vineyard Glassworks
1078 State Road, West Tisbury | www.mvglassworks.com

Who knew that watching glass blowing could be so enjoyable? Not only are the demonstrations interesting, but the store itself is somewhat of a surprise. Half the building is the workshop with unobstructed views, so you can easily observe the craftsmen heating and shaping their glass pieces. The other side of the building is an amazing kaleidoscopic showroom filled with a diverse collection of world-class, hand-blown bowls, vases, and other stunning glass pieces. The MV Glassworks is like a glass museum, shimmering with a multitude of color.

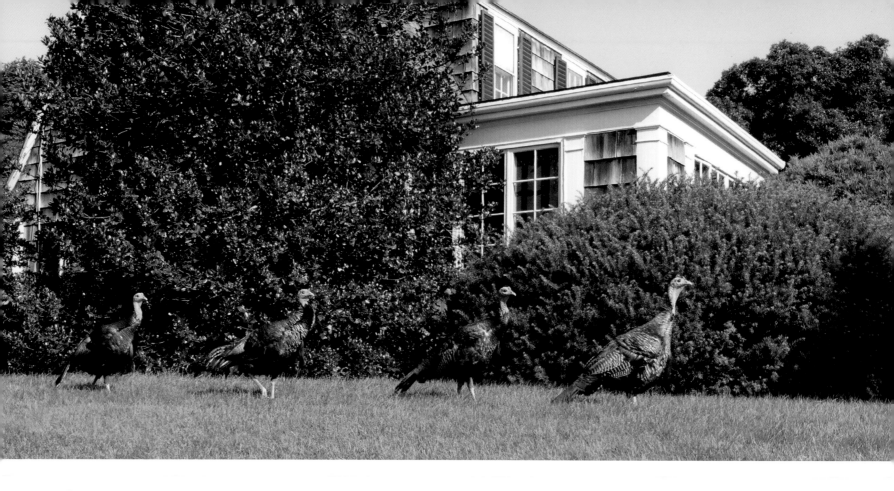

No. 35

Try to catch one of the many wild turkeys running free on the island

Wild Turkeys
Vineyard Haven

The wild turkeys on Martha's Vineyard seem to be everywhere nowadays. You'll find them gathering on front lawns, strutting their stuff crossing roadways, or hanging out on fences. They seem to move slowly, but these turkeys have moves! Zigging and zagging in every direction, they are fast little creatures. Go ahead and try to chase one down. And good luck with that!

No. 36

Enjoy the hand-crafted beer and drop the peanut shells on the floor at the Offshore Ale Brewery in Oak Bluffs

Offshore Ale Company Brewery
30 Kennebec Avenue, Oak Bluffs | www.offshoreale.com

Grab a bowl of peanuts from the signature barrel on your way through the door, and belly up to the bar for some great craft beer brewed right here in Oak Bluffs. Or choose to be seated at a table in the large open dining room filled with buoys, flags, and a wooden canoe. Either way, enjoy the peanuts, and feel free to throw your shells on the floor. And if you have time, go ahead and tour the brewery.

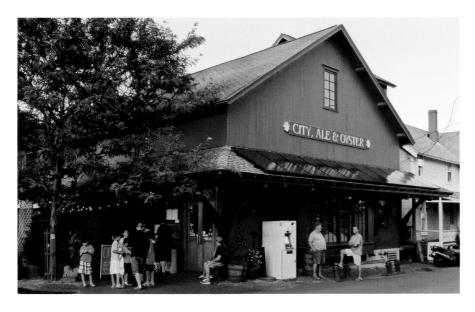

No. 37

Get a fresh, hot doughnut through the kitchen door until 12:59 a.m. at Back Door Donuts

Back Door Donuts
Behind Martha's Vineyard Bakery, Oak Bluffs | 508-693-3688

What started out as a clandestine operation has blossomed into the island's best late-night snack destination. If you are in Oak Bluffs after sunset you will surely smell that delicious aroma of freshly baked doughnuts coming from behind the bakery. So get in line, 'cause they're selling them out the back door! Just one bite into a delicious hot apple fritter is worth the wait!

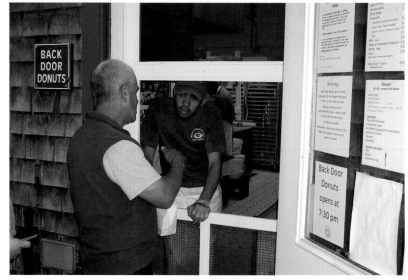

No. 38

Go for a nature hike up to Prospect Point in Menemsha Hills Reservation, one of the highest elevations on the island

Prospect Point
Off North Road, Chilmark
978-921-1944

Prospect Point, at 308 feet above sea level, is the second highest elevation on the island. It's located in Menemsha Hills Reservation, a 211-acre preserve with over three miles of trails that wind past wetlands, holly, black cherry trees, and high-bush blueberries. You can take the short route to the point, where you'll find a dazzling panorama extending from the Elizabeth Islands, past the shores of Menemsha, and all the way to Noman's Island. Tip: Venture down the longer path to the rocky beach, and you'll find an area that was used as a military lookout during World War II.

No. 39

Rent a moped and visit all three major towns—Edgartown, Oak Bluffs & Vineyard Haven—in one afternoon

Sun 'n' Fun Moped Rentals
28 Lake Avenue, Oak Bluffs | www.sunnfunrentals.com

Scooters can be an adventurous way to see a good part of the island in a short period of time at your own pace, especially since the main towns are in fairly close proximity. They're a lot of fun and cheaper than cars, but you really need to use caution. With all the sand and narrow roadways, mopeds can be a bit of a dangerous way to get the job done—so be careful.

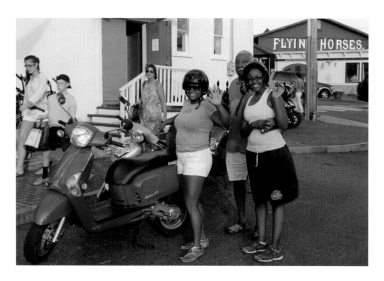

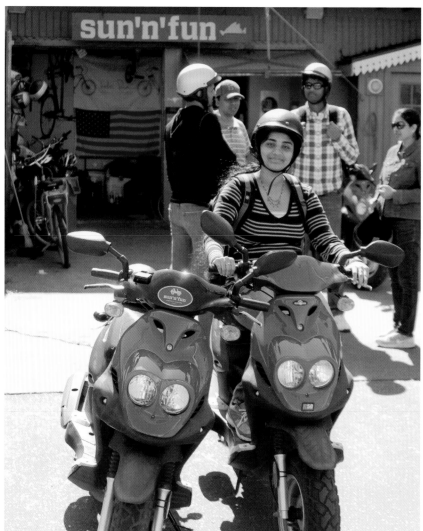

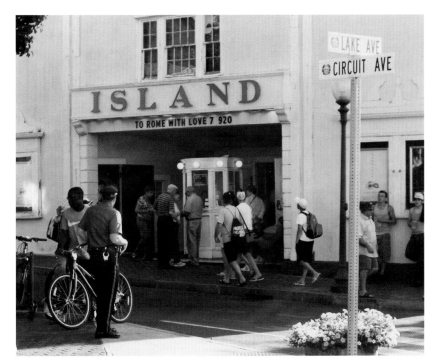

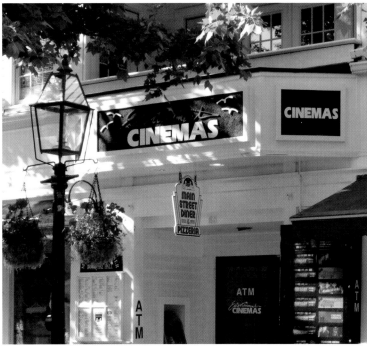

No. 40

Go to the movies at one of the island's historic theaters: the Strand, Island Theatre, or Edgartown Cinemas

Island Theatre
1 Circuit Avenue, Oak Bluffs

Ah, the Big Screen! To get that old-time theater experience and to watch a movie on the big, big screen you have to visit the Island Theatre at the end of Circuit Avenue in Oak Bluffs. You can usually expect a long line as tickets are not sold in advance, but you can enjoy the smell of fresh popcorn as you wait!

Edgartown Cinemas
65 Main Street, Edgartown

Nestled amongst Edgartown's shops, restaurants, bars, and inns on Main Street, Edgartown Cinemas is probably the most popular spot on the island to take in a movie. It has two intimate theaters with comfy seats and is generally considered the island's more modern theater. You'll see first-run movies here, and you can buy tickets in advance.

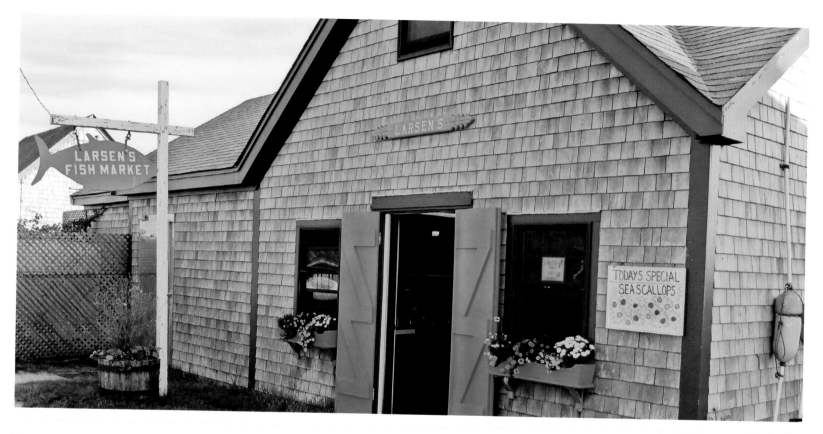

No. 41

A must-do: get a steamed lobster at Larsen's Fish Market then watch the sunset on the beach in Menemsha

Larsen's Fish Market
56 Basin Road, Menemsha Harbor | www.larsensfishmarket.com

If you travel to Martha's Vineyard and don't get a steamed lobster and watch sunset on the beach in Menemsha, you blew it! This is by many accounts the #1 thing to do on the island. You'll need to call ahead to reserve your sunset lobsters, scallops, chowder, and steamers. Don't forget the melted butter. Then walk down the street, spread out a blanket or some beach chairs, and watch the sunset on the beach. Unforgettable!

Fresh Seafood at Larsen's
56 Basin Road, Menemsha Harbor

Larsen's is not just a great place for sunset lobsters, it's also a real "old school" fish market. Located right on the docks, Larsen's is nestled in among a few other shops and local markets. If you are in Menemsha anytime during the day, stop in and get some fresh seafood right off the boats.

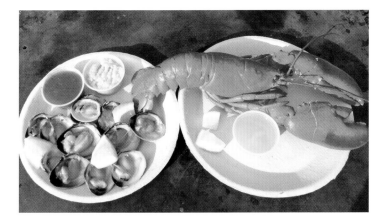

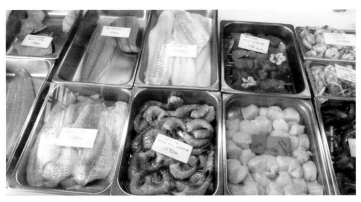

Behind Larsen's Fish Market
56 Basin Road, Menemsha Harbor

You don't necessarily have to take your freshly steamed lobsters and seafood to the beach. One of the best seats for dining on the island is right here on the long, worn wooden benches behind the market. Facing the fishing boats with the sunshine smiling down on you, join your friends and enjoy a feast to remember!

No. 42

Don't forget to take a bottle of wine to sunset!

Sunset on Menemsha Beach
Menemsha Beach

There is really only one spot on the island where everyone gathers to watch the brilliant, colorful sunsets, and that's Menemsha Beach. Grab your lobster, a beach towel or chair, and a loved one, and watch Mother Nature do her thing! Tip: Menemsha sunsets get very, very busy during the summer season. If you are driving to sunset, as most do, arrive early, or chances are that you will not be able to find a place to park.

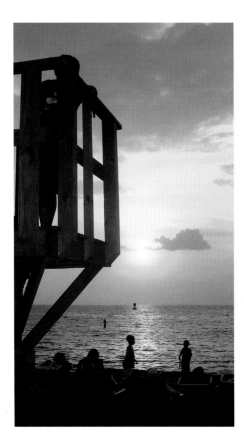

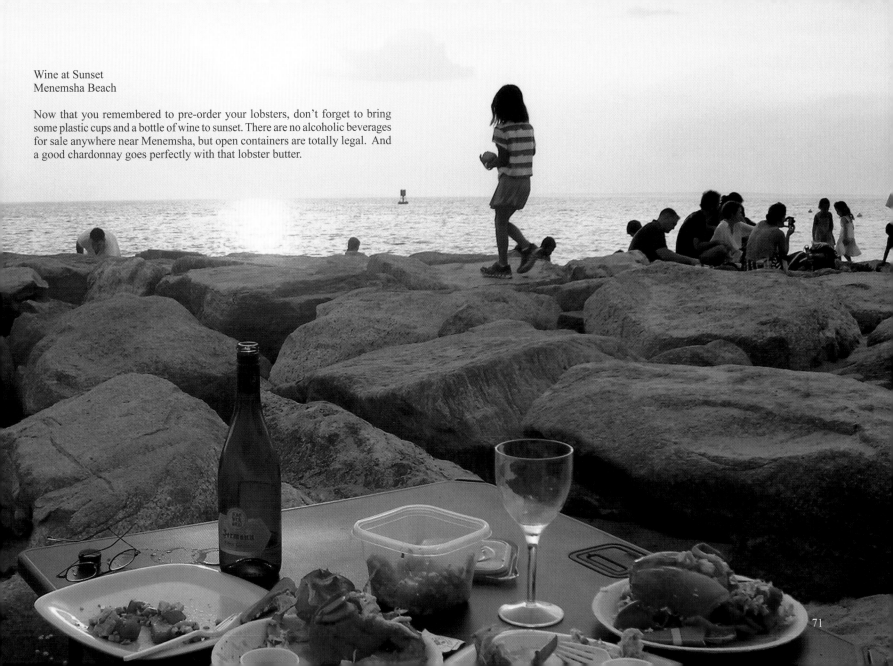

Wine at Sunset
Menemsha Beach

Now that you remembered to pre-order your lobsters, don't forget to bring some plastic cups and a bottle of wine to sunset. There are no alcoholic beverages for sale anywhere near Menemsha, but open containers are totally legal. And a good chardonnay goes perfectly with that lobster butter.

71

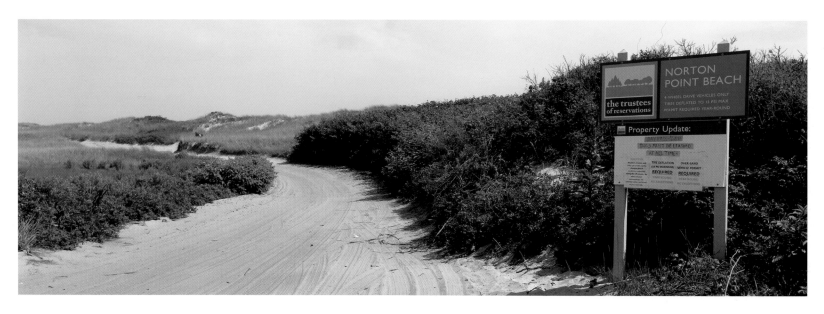

No. 43

Rent a Jeep, get an over-sand permit, and go crazy riding the dune trails just off South Beach

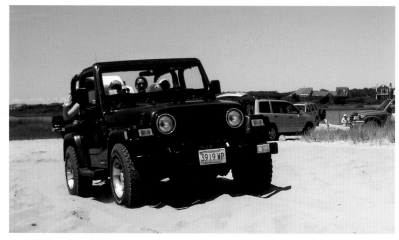

Dune Trails
Norton Point Beach, Katama

For a thrilling experience, rent a Jeep and drive around the dune trails just off South Beach in Katama. There are fourteen miles of trails that zigzag all the way out to Cape Pogue. Or join in the line of Jeeps parked facing the ocean on Norton Point Beach, and enjoy the sand and the surf. Tip: Always check ahead with the trustees, as access on the trails can change daily!

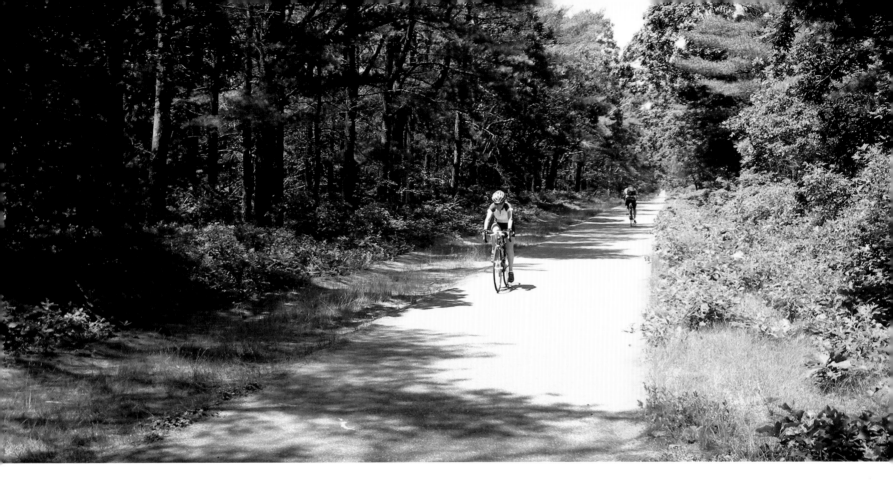

No. 44

Get yourself a bike, and ride the ten-mile loop in and around Manuel F. Correllus State Forest

Manuel F. Correllus State Forest
West Tisbury

While there are many great bike routes on the island, the State Forest route might just be the least well known. This five-thousand-acre gem in the middle of the island is hidden in plain sight. Its ten-mile loop is smooth and well paved, with the giant trees providing that wonderful pine smell and lots of cool shade. The sense of peace and the quiet desolation on this route is just awesome.

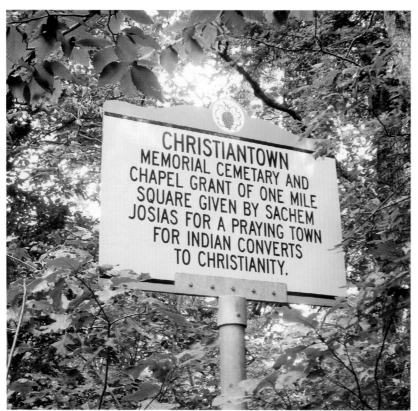

CHRISTIANTOWN
MEMORIAL CEMETARY AND
CHAPEL GRANT OF ONE MILE
SQUARE GIVEN BY SACHEM
JOSIAS FOR A PRAYING TOWN
FOR INDIAN CONVERTS
TO CHRISTIANITY.

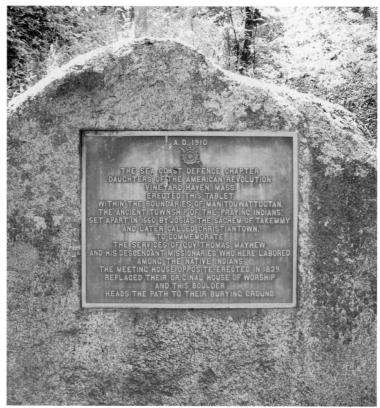

A.D. 1910
THE SEA COAST DEFENCE CHAPTER
DAUGHTERS OF THE AMERICAN REVOLUTION
VINEYARD HAVEN, MASS.
ERECTED THIS TABLET
WITHIN THE BOUNDARIES OF MANITOUWATTOOTAN,
THE ANCIENT TOWNSHIP OF THE "PRAYING INDIANS"
SET APART IN 1660 BY JOSIAS THE SACHEM OF TAKEMMY
AND LATER CALLED CHRISTIANTOWN,
TO COMMEMORATE
THE SERVICES OF GOV. THOMAS MAYHEW
AND HIS DESCENDANT MISSIONARIES WHO HERE LABORED
AMONG THE NATIVE INDIANS.
THE MEETING HOUSE OPPOSITE ERECTED IN 1829
REPLACED THEIR ORIGINAL HOUSE OF WORSHIP
AND THIS BOULDER
HEADS THE PATH TO THEIR BURYING GROUND.

No. 45

Hike the trails around the Mayhew Chapel and Indian Burial Grounds in West Tisbury

Christiantown
Christiantown Road, West Tisbury

The Wampanoag Tribe established the community known as Christiantown back in the 1640s. If you are adventurous, travel deep into the wooded area down bumpy Christiantown Road, where you will find the Mayhew Chapel, which dates back to 1680, and the old Indian Burial Grounds. Just beyond the chapel, you'll find some narrow little paths for hiking.

No. 46

Visit the Vincent House, the oldest residence on the island, built in 1672

The Vincent House
99 Main Street, Edgartown

For a taste of island history, visit the Vincent House, the oldest residence on the island. The structure was built in 1672 by William Vincent and was lived in by five generations of his descendants. It's furnished with period antiques depicting island life throughout four centuries. Guided tours are offered by the Martha's Vineyard Preservation Trust. Call ahead for times and tour package options.

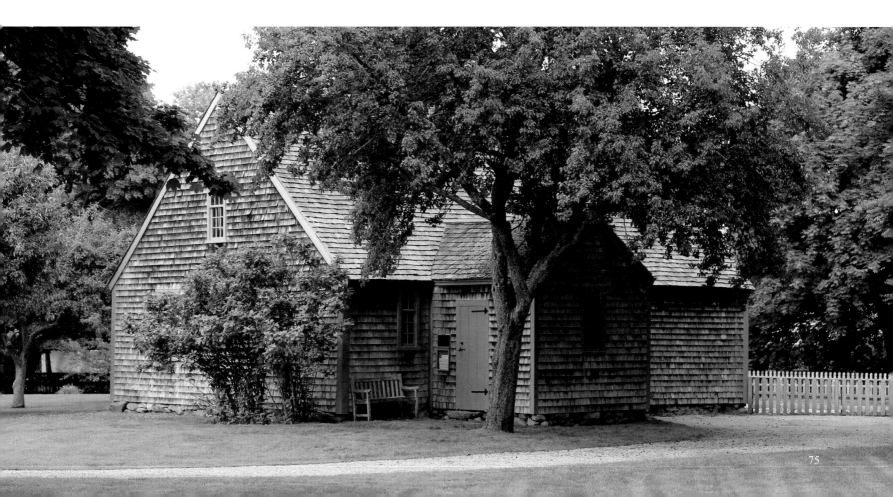

No. 47

Mix-n-match your favorite homemade candies at Chilmark Chocolates

Chilmark Chocolates
19 State Road, Chilmark | 508-645-3013

This is one tiny little chocolate shop that lives up to all the hype. Simply put, it's the best darn chocolate you will ever have. Just pick your box size or a little paper bag at the front door, then move down the line. The counter person will fill your container up with as many varieties as you like from the display case: caramels, cranberry or blueberry clusters, glazed apricots, crushed toffee—everything smothered in chocolate, and they are all yummy! Have your choices weighed at the end of the counter and exit out the rear door. Gotta keep that long line moving. Tip: The shop hours are very limited, so check times before heading out.

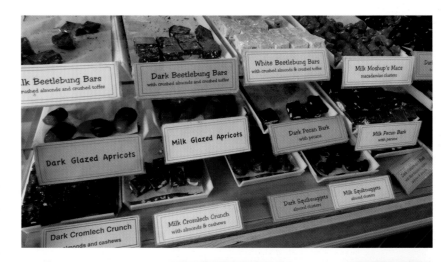

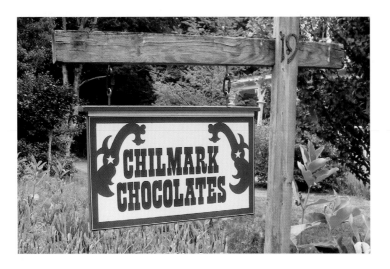

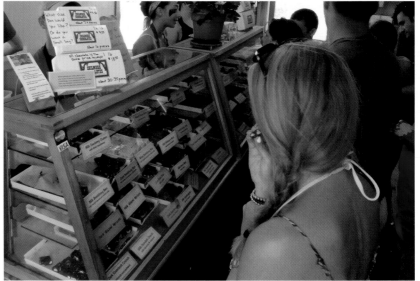

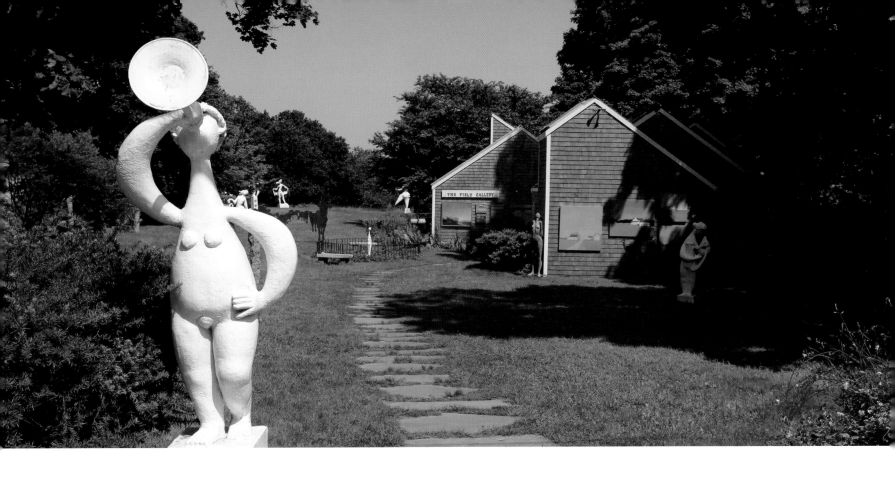

No. 48

Check out the artful creations at
the Field Gallery & Sculpture Garden
in West Tisbury

The Field Gallery & Sculpture Garden
1050 State Road, West Tisbury | www.fieldgallery.com

Established in 1970, The Field Gallery is another one of the must-see "things to do" on Martha's Vineyard. Inside the gallery are three spaces with rotating exhibits, while the outside is home to dancing bronze sculptures and whimsical resin statues created by gallery founder Thomas Maley. The gallery is located right across the street from Alley's General Store. Tip: Check out one of the artist's receptions held every Sunday afternoon in the summertime.

NO. 49

Go see the alpacas, and take the tour of the nineteen-acre Island Alpaca Farm

Island Alpaca Company Farm
1 Head of the Pond Road, Oak Bluffs | www.islandalpaca.com

Located off Edgartown-Vineyard Haven Road, the Island Alpaca Company has over sixty colorful Huacaya alpacas roaming their pastures. These gentle animals are bred and raised here in Oak Bluffs for their high-quality fleece, which is soft as cashmere and three times warmer. Be sure to take the discovery tour where you'll not only learn about the alpacas but also get a chance to feed and walk them. And check out the cute little gift shop adjacent to the antique barn. It's full of scarves, hats, sweaters, gloves, and everything alpaca!

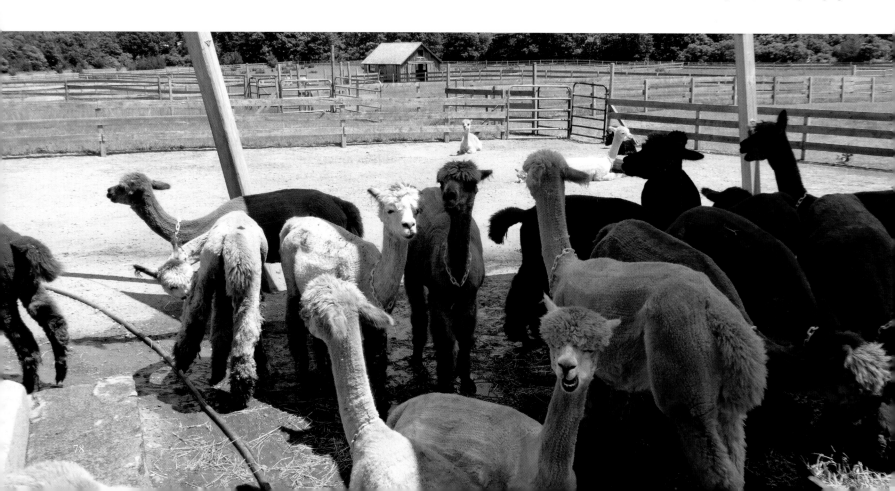

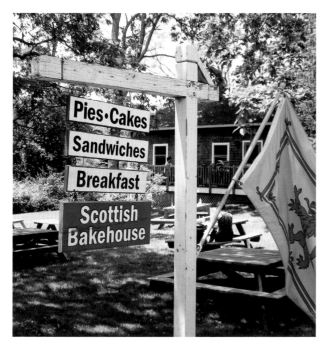

No. 50

Enjoy the island's best breakfast sandwich or pick out a yummy pastry at the Scottish Bakehouse in Tisbury

Scottish Bakehouse
977 State Road, Tisbury | www.scottishbakehousemv.com

This hip little Scottish Bakehouse is just a bit outside Vineyard Haven, so you'll need a car or bike to get there, but it's well worth the visit! Opened in 1961, the bakehouse is essentially a take-out place, but it does have a small deck and a large front lawn filled with picnic tables. The bakery is frequently voted best on the island, but it's their breakfast sandwich that is a must in the morning. And everything is made to order, so the wait can be a bit long. Tip: Check out the online menu and call your order in ahead of time!

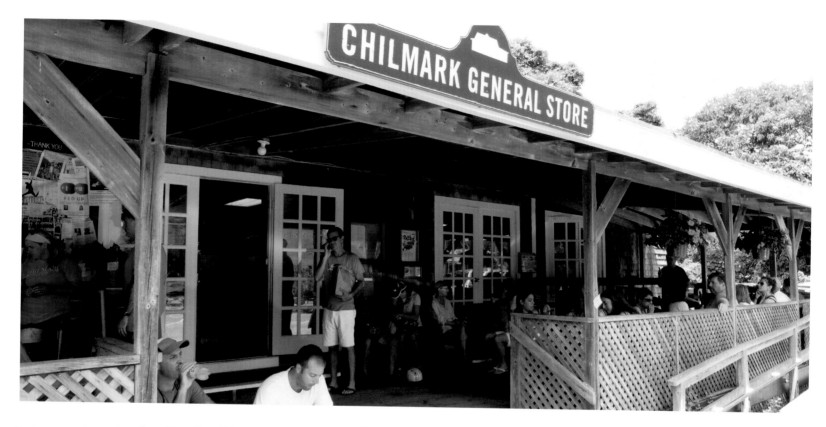

No. 51

Have a slice of pizza, and watch for famous faces from a front-porch rocking chair at Chilmark General Store

Chilmark General Store
7 State Road, Chilmark | www.chilmarkgeneralstore.com

Much more than a general store, this old-fashioned market is *the* gathering spot for locals, celebrities, and tourists alike. Yes, it is one of the very few places to shop for groceries Up-Island, but it's the pizza counter and large New England–style front porch filled with lots of shade and rocking chairs that make you just want to hang out for a spell. Many of the famous folks that live on the island reside near the Chilmark area, so don't be surprised if someone like Carly Simon should walk up the steps. Just smile and grab another slice of pizza.

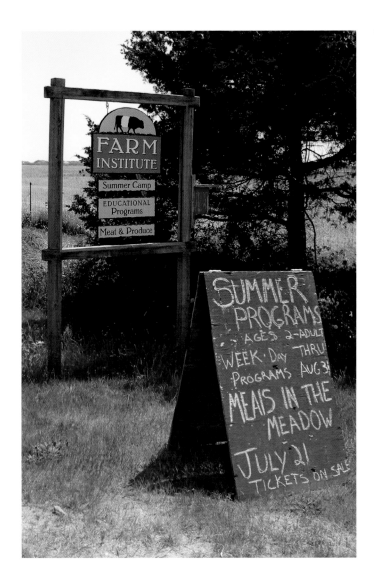

No. 52

Learn about sustainable agriculture and play farmer at The Farm Institute near Katama Airfield

The Farm Institute
14 Aero Avenue off Katama Road, Katama | www.farminstitute.org

The Farm Institute is a wonderful 160-acre teaching farm that educates and engages young and old about sustainable agriculture. You could spend a whole day attending workshops, doing farm chores, or just having a delightful time playing with all the farm animals. Check out their calendar for current events, then stop on over and milk the goats, feed the chickens, watch baby piglets being born, and tend the vegetable garden!

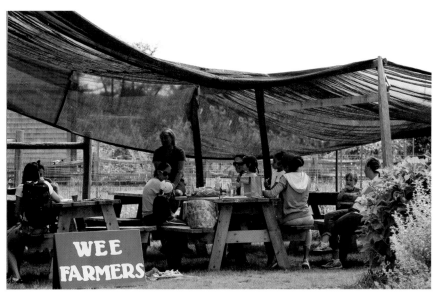

No. 53

Hang out at the bars and restaurants overlooking the boats in the harbor at the Oak Bluffs Dockside Marketplace & Marina

Oak Bluffs Dockside Marketplace & Marina
Oak Bluffs Harbor, Oak Bluffs | www.mvdockside.com

The heartbeat of the waterfront action on the island can be found up and down the boardwalk that surrounds this popular, active marketplace harbor. Beautifully scenic and bustlingly busy both day and night, there are dozens of open-air bars and restaurants with sunny porches that are always crowded. The Oak Bluffs Marina is a great place for old and young alike to ogle the sailboats and the yachts docked in and along the harbor. Belly up to a bar stool, order up some raw bar favorites, and enjoy the view. It's a great place to people-watch as well!

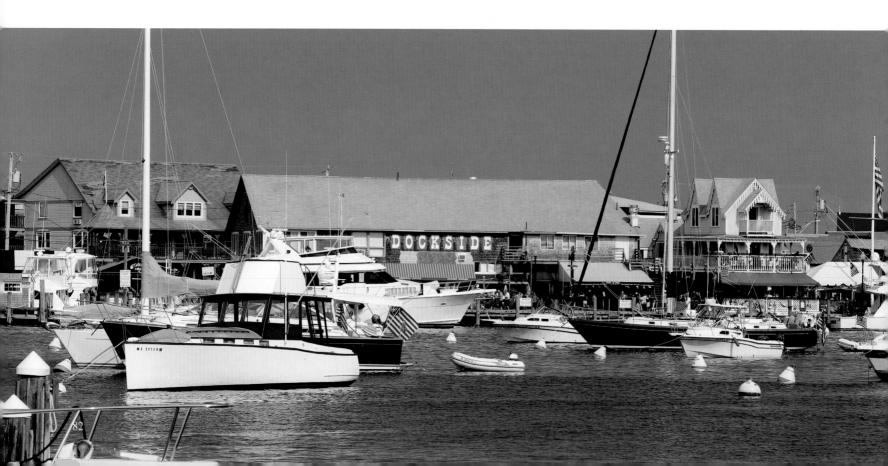

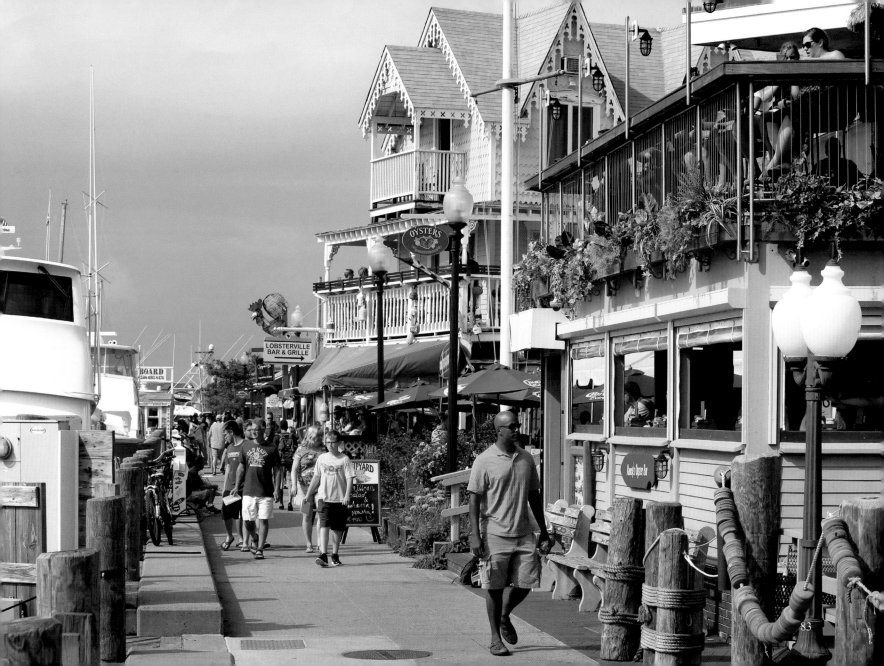

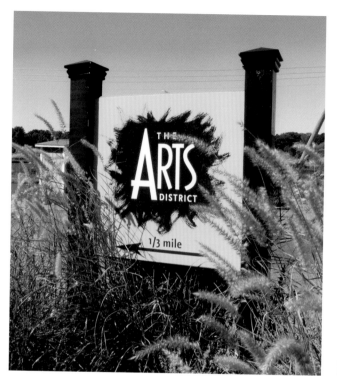

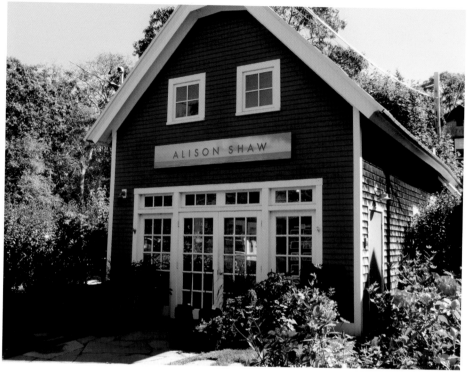

No. 54

Shop at the galleries and boutiques in the Arts District along Dukes County Avenue in Oak Bluffs

The Arts District
Dukes County Avenue, Oak Bluffs

The Arts District is a wonderful little concentration of shops and galleries located on Dukes County Avenue right on the edge of the "campground." The district features fine art and photography, as well as jewelry and clothing boutiques. Tip: Check out the district's mini stroll on Thursday evenings.

Alison Shaw Gallery
88 Dukes County Avenue, Oak Bluffs
www.alisonshaw.com

Alison Shaw's colorful gallery is located in the former Oak Bluffs firehouse in the heart of the district. Be sure to have a look at the fine photographic images from this popular and critically acclaimed photographer. Fine art, books, and beautiful note cards are also available in her shop.

No. 55

Photograph the famous pagoda tree, the oldest on the continent, planted in 1837

Giant Pagoda Tree
South Water Street, Edgartown

The majestic captains' mansions that line South Water Street in Edgartown are dominated by this huge Japanese pagoda tree, which was brought from China in 1837 as a seedling in a flower pot. It was brought by Captain Thomas Milton to grace the home he was building at that time. The pagoda tree is believed to be the oldest of its kind on the continent. It is a beauty to behold, and a sight to be seen.

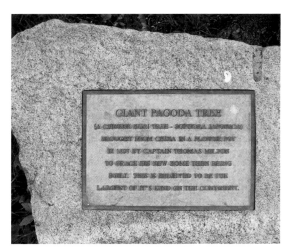

No. 56

Look in awe at the more than 30,000 items in the Martha's Vineyard Museum

Martha's Vineyard Museum
59 School Street, Edgartown | www.mvmuseum.org

Tucked away on the corner of Cooke and School Streets in a residential neighborhood in Edgartown is Martha's Vineyard's historical museum. More than just a museum, the facility features outdoor exhibits, a reference library, and the remarkably preserved eighteenth-century Cooke Family House. Spend an afternoon and really get to know the island, historically speaking.

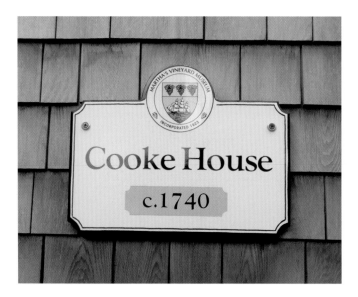

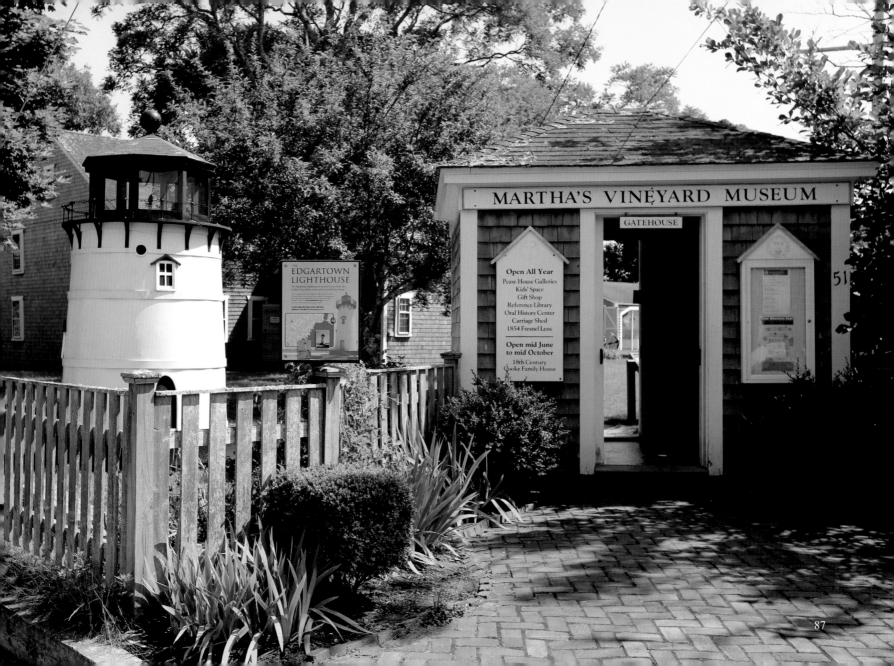

MARTHA'S VINEYARD MUSEUM

GATEHOUSE

THE
EDGARTOWN
LIGHTHOUSE

Open All Year
Pease House Galleries
Kids' Space
Gift Shop
Reference Library
Oral History Center
Carriage Shed
1854 Fresnel Lens

**Open mid June
to mid October**

18th Century
Cooke Family House

51

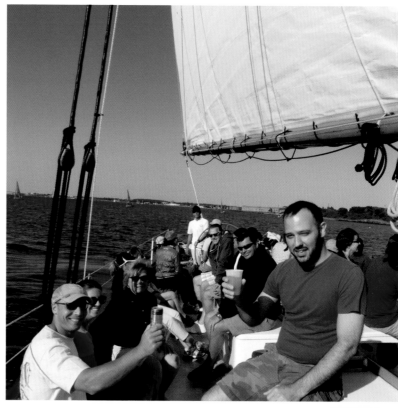

No. 57

Have a ton of fun out on the ocean on a booze cruise

Booze Cruise
Oak Bluffs Harbor, Oak Bluffs

You can take all kinds of charters, trips, and cruises from the many private charter boats that line the harbor, but the most fun you can have out on the water might be on a booze cruise. Why not see all those magnificent ocean views with a glass of wine or a rum runner in your hand? Like the sign says, "You can catch bluefish, tuna, or shark . . . or a real good buzz!" Cheers, everybody!

No. 58

Rent a kayak or a canoe from Winds Up! on Beach Road, and paddle the day away

Winds Up! Natural Watersports
199 Beach Road, Vineyard Haven | www.windsupmv.com

Canoes, kayaks, paddle boards, windsurfers, and everything you'll need to enjoy natural water sports are readily available right along sedate Sengekoutacket Pond. Well known as the best place to kayak, the pond's 745 acres can take you up close to Felix Neck's wildlife, where you might get the opportunity to observe the ospreys and their nests. For added adventure, you can paddle under the bridge and out to the Atlantic Ocean.

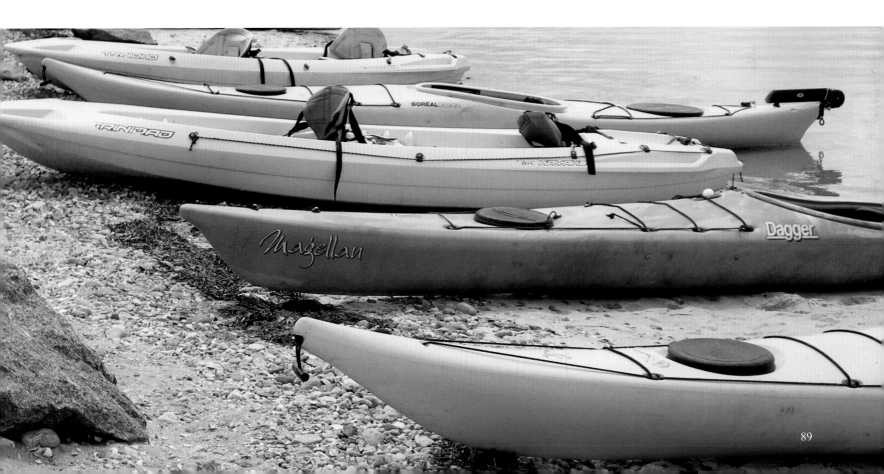

o see live professional theater
the Martha's Vineyard Playhouse
Vineyard Haven

Martha's Vineyard Playhouse
24 Church Street, Vineyard Haven | www.vineyardplayhouse.org

The performances at this professional nonprofit community theater have always shined brightly, and now the building does as well. Built in 1833, the entire playhouse was recently renovated and expanded, and it just sparkles. New and classical plays and musicals are performed year-round in this charming, historic theater. Check out their schedule, then be prepared to be amused, touched, and inspired by live theater at its best.

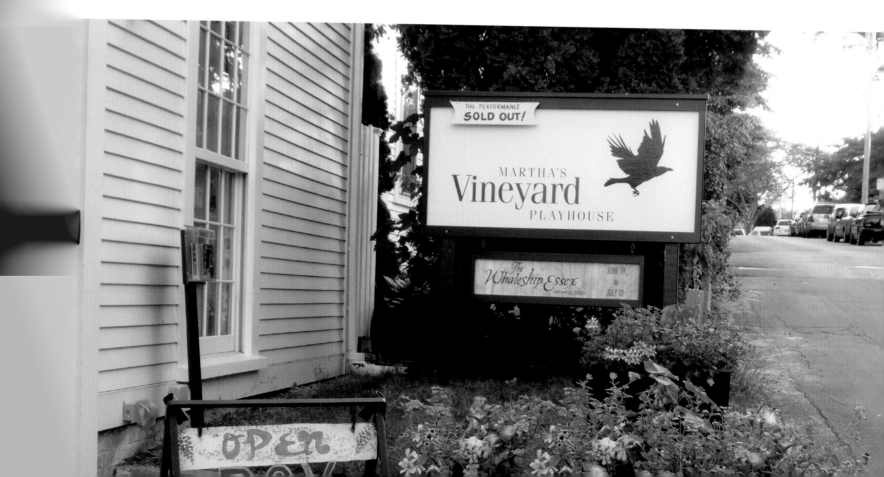

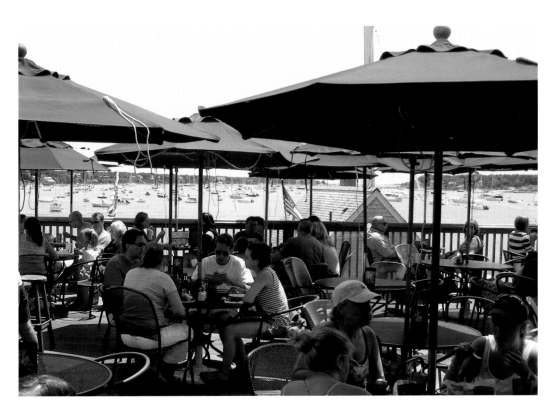

No. 60

Enjoy a Dark 'n Stormy on the sunny second-floor deck at The Seafood Shanty in Edgartown

The Seafood Shanty
31 Dock Street, Edgartown
www.theseafoodshanty.com

There is no better spot on the island to enjoy great seafood and a cold beverage on a sunny afternoon than the second-floor deck at The Seafood Shanty. Expect spectacular views of the harbor filled with yachts and sailboats from your umbrella-shaded table. Tip: The Shanty sushi menu is generally considered the best on the island!

Dark 'n Stormy
The Seafood Shanty, Edgartown

If you haven't tried one before, now's the time! The Dark 'n Stormy is a favorite of the sailing set, so needless to say, it's very popular on the island. A delicious combination of dark rum and ginger beer garnished with a lime, this drink tastes like summer. And the best one you'll ever have is found at The Shanty.

No. 61

Take a late-afternoon stroll down Circuit Avenue in Oak Bluffs, and look into all the neat shops

Circuit Avenue
Oak Bluffs

If you are visiting the island for the first time, you're probably going to end up on Circuit Avenue at some point. Lots of quirky whimsical shops and small boutiques line both sides of the street on this main drag in Oak Bluffs. Mix in ice cream, souvenirs, an arcade, and affordable food, and you've got a great way to spend your late afternoon.

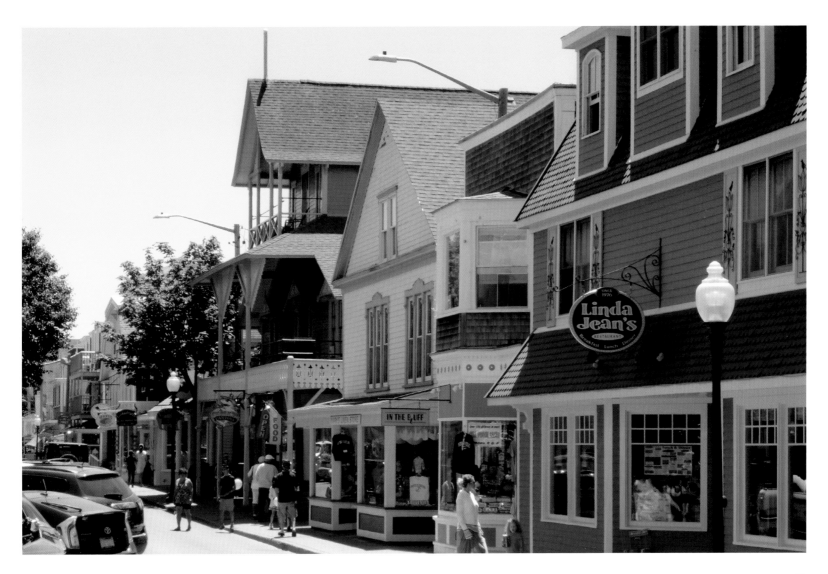

No. 62

Listen to some great live local music at the clubs and restaurants in Edgartown or Oak Bluffs

Rare Duck Lounge / Lampost Bar
6 Circuit Avenue, Oak Bluffs | 508-693-4032

If you still have some energy left for live entertainment after spending your day in the hot sun, you've got lots of nighttime options. National and local rock, reggae, rap, and electronic bands pack in the summer crowds from Edgartown to Oak Bluffs. One of the local favorite spots is the Rare Duck Lounge, located right beneath the Lampost Bar. Tip: Check out the listings in the *MV Times* to find out what's currently happening at the Lampost and all over the island.

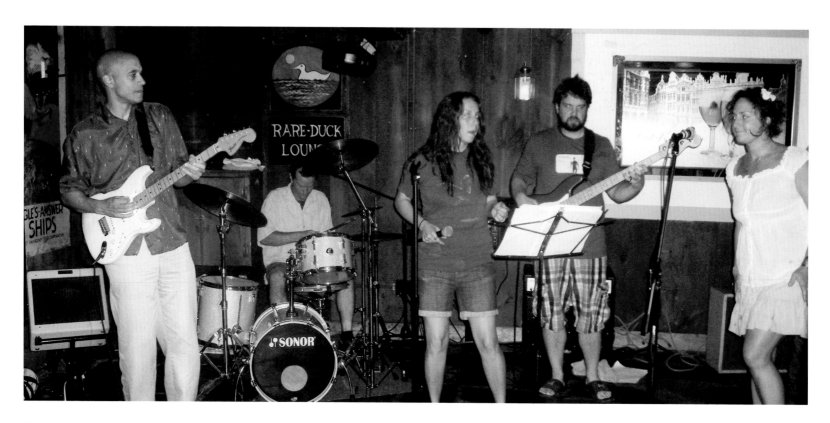

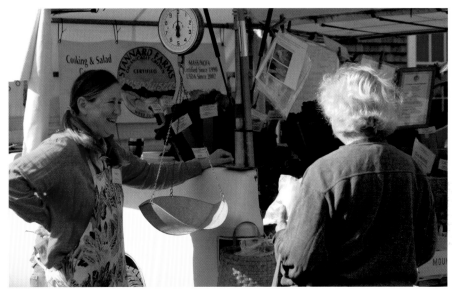

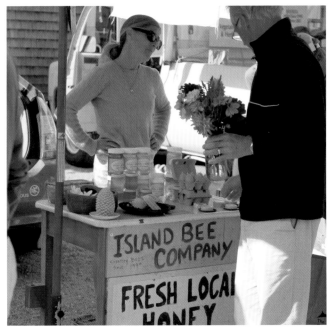

No. 63

Go to the outdoor West Tisbury Farmers Market on Wednesdays or Saturdays

West Tisbury Farmers Market
1067 State Road, West Tisbury | www.westtisburyfarmersmarket.com

It's a feast for the senses! West Tisbury holds their long-running outdoor farmers market every Wednesday and Saturday from 9 a.m. until noon. Freshly made jams and mustards, locally grown fruits and veggies, freshly baked breads, colorful flowers—they're all grown or produced right here on Martha's Vineyard. And all of the goods are sold from tents, tables, and the backs of trucks. Now isn't that how it should be done?

No. 64

Pretend you're rich and famous by walking around inside one of the many fine-art galleries

Eisenhauer Gallery
38 North Water Street, Edgartown | www.eisenhauergallery.com

There are an abundance of good art galleries on the island, but my favorite is the Eisenhauer Gallery in the heart of Edgartown on North Water Street. The Eisenhauer features a great selection of contemporary local and international works. It is also one of the most colorful, diverse, and unique galleries on the island. And it's easy to find. Just look for David Phelps's triple-life-size bronze sculpture *The Pastoral Dreamer* resting peacefully in the courtyard.

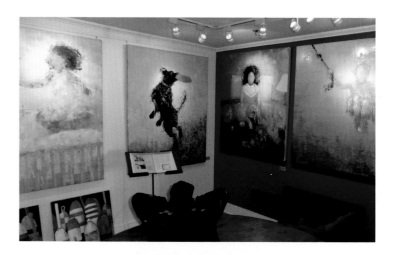

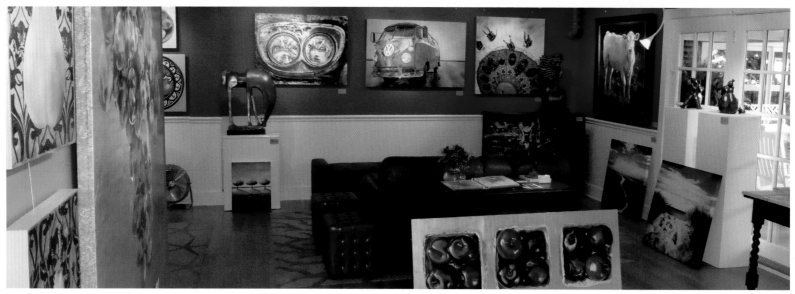

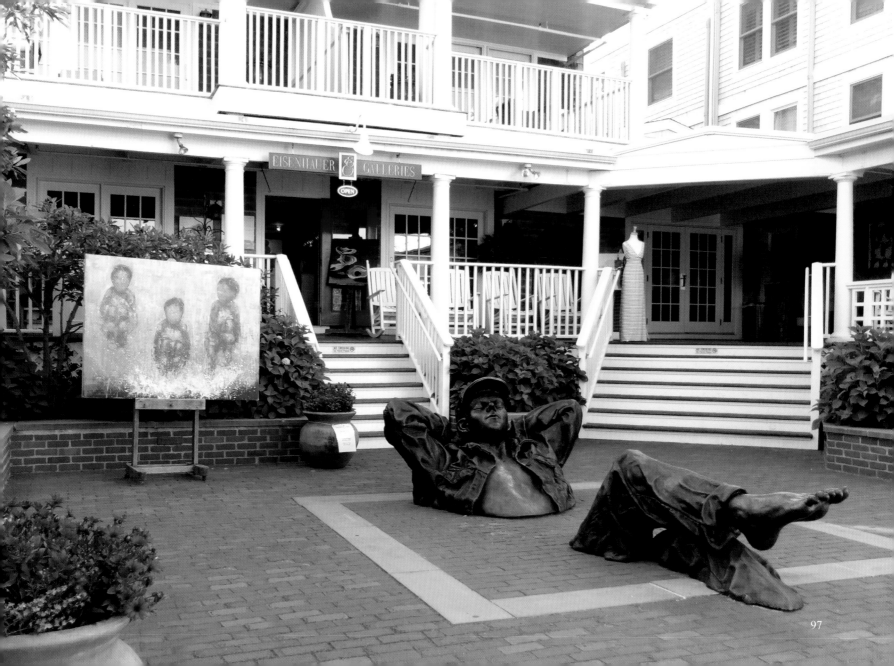

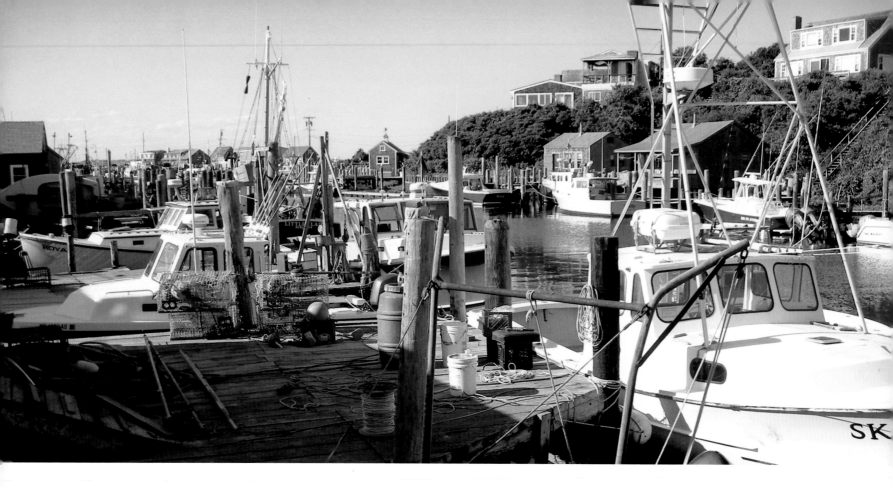

No. 65

Walk amongst the fishing boats in Menemsha, and see where the movie *Jaws* was filmed

Menemsha Harbor
Menemsha

Menemsha Harbor has been home port for generations of fishing families. It's also a great place to soak up some local color. The smell of fish and salt water will be unmistakable as you wander around the winding docks crowded with ropes, lobster cages, and fishing boats. Visit the docks in the late afternoon, when you can get a close-up view and chat with the fishermen returning from the sea and unloading their catch. You might also recognize this active harbor from the movie *Jaws*.

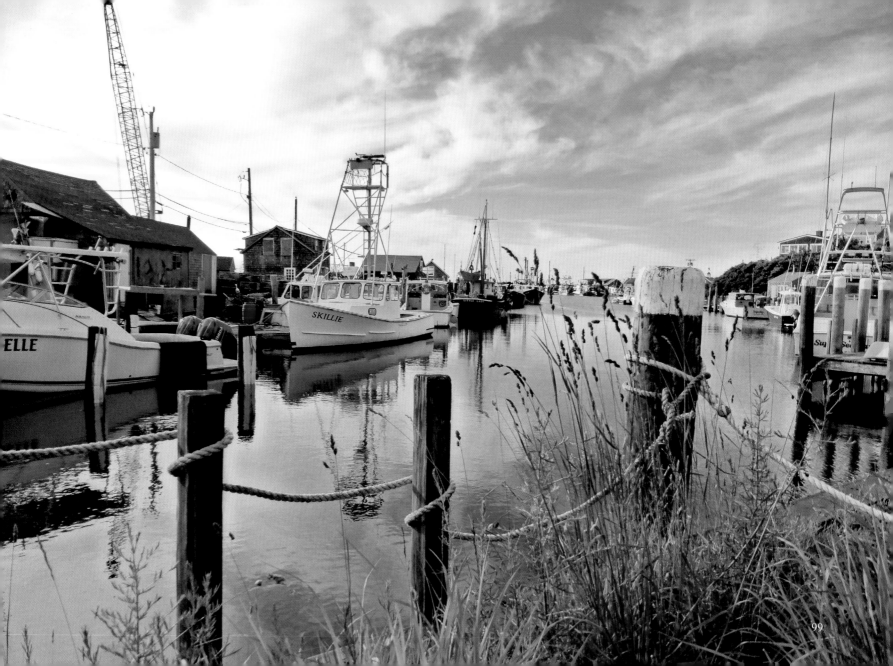

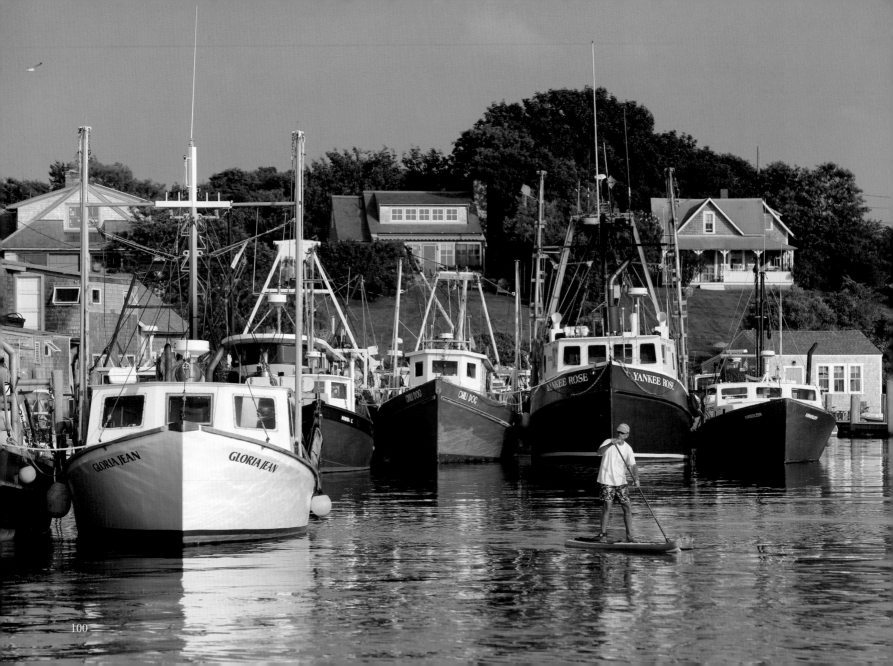

No. 66

Attend an outdoor yoga class with Rock outside Atria Restaurant in Edgartown

Yoga Class led by Rock
137 Main Street, Edgartown

Bending, stretching, twisting, and sweating; if you are on the island and need to get your yoga on and move your spirit into a pristine expanse of pure energy, this is the place. Rock has been presiding over early morning yoga classes on Atria's tented patio deck for years. Don't forget to drop a donation in the basket. Namaste! Tip: The classes are held outside Atria Restaurant, one of the finer restaurants on the island. Be sure to check out their menu posted out front. They also have a fantastic brick-cellar bar in the basement featuring live entertainment. Another must-do!

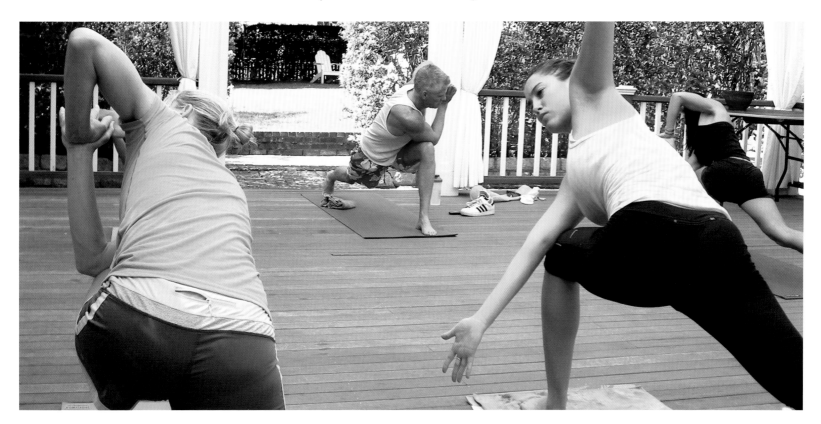

No. 67

Visit one of the many turn-of-the-century general stores on the island

Alley's General Store
1045 State Road, West Tisbury | 508-693-0088

If you're headed Up-Island, stop in at the oldest general store on the Vineyard. Alley's has been in business since 1858, and the store still looks that way! Packed with fishing lures, nuts, comic books, candy bars, groceries, and beach supplies, there's something for everyone. And they are open year-round.

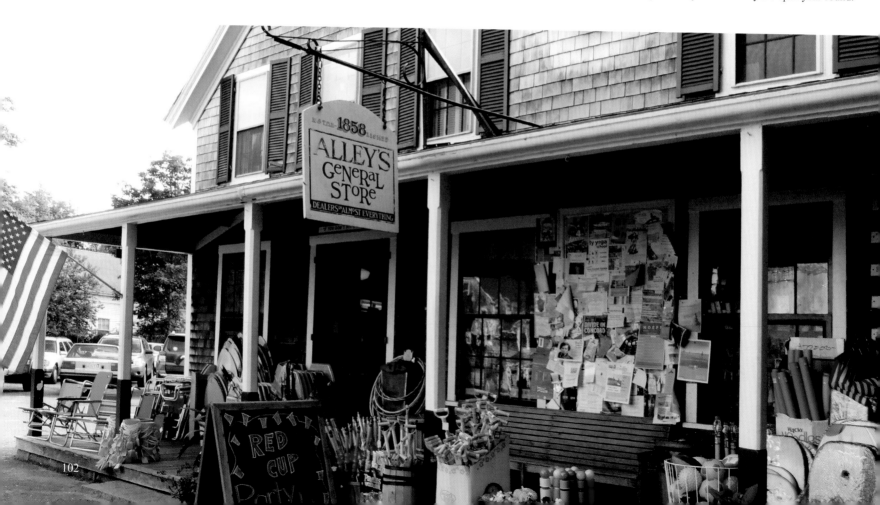

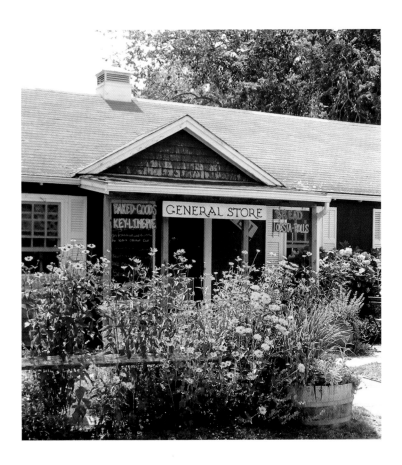

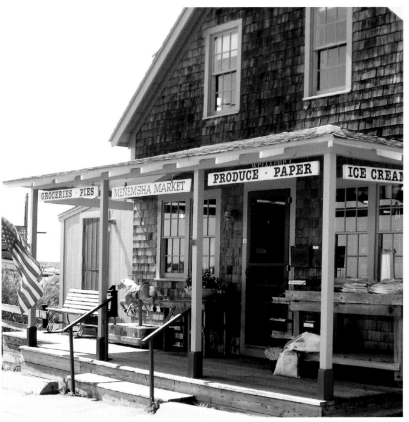

Katama General Store
107 Katama Road, Edgartown | 508-627-5071

A must-stop on your way to South Beach, this rustic little store surrounded by flowers has everything you might need for a picnic or the beach. Lots of cold beverages and unique, pre-packed sandwiches are available. Charming on the outside, the store has more of a gourmet flavor on the inside.

Menemsha Market
511 N Road, Menemsha | 508-645-3501

Across from the Homeport Restaurant, the Menemsha Market is one of the few places that stocks the convenience items you might need when visiting this quaint fishing village. Upside: They carry fresh Up-Island produce, and they have the only ATM machine around. Downside: For some reason they no longer carry newspapers. Bummer.

Sailing into the Sunset
Menemsha Beach, Menemsha

No. 68

Rent your own sailboat, and sail into the sunset

There are many beautiful sights to be seen on Martha's Vineyard, but maybe none as unforgettable as sailing into one of the island's sunsets. Each sunset is special, accompanied by an indescribable sense of peace and quiet that only an ocean can bring. Rent a sailboat while you are here and sail away from the madding crowds into an evening's sunset.

No. 69

Join the crowd jumping off the wooden drawbridge into the water at State Beach

Jumping off the *Jaws* Bridge
Beach Road between Oak Bluffs & Edgartown

Step atop the railing along the wooden drawbridge at the Joseph A. Sylvia State Beach, and your heart has to be pounding. It sure does seem like a long way down to the water. But it's packed with kids lining up all summer long just to get their chance to perform an outrageous jump. This famous bridge, also known as the American Legion Bridge, is right on Beach Road and yes, you do recognize it from the movie *Jaws*. Tip: The island bus stops here!

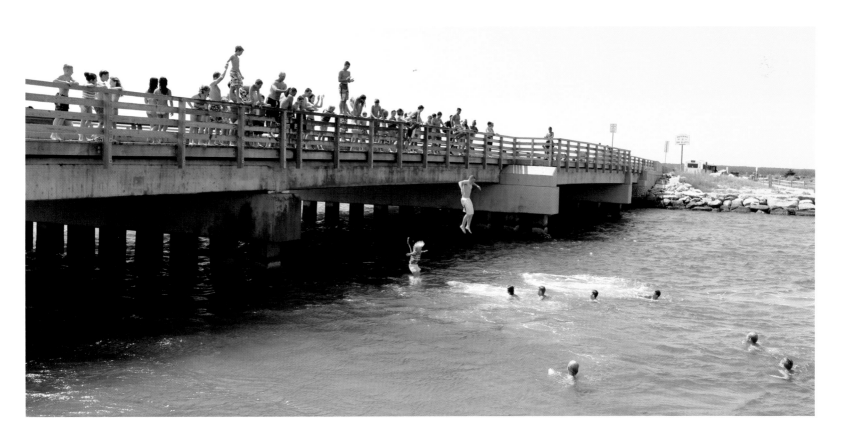

No. 70

Walk the footpaths
of Mytoi Gardens,
a fourteen-acre
Japanese-style
garden filled with
exotic plants

Mytoi Japanese Gardens
Dike Road, Chappaquiddick
508-627-7689

If you are headed over to Chappy, be
sure to check out this intimate Japanese
garden set within an open pine forest.
The gardens are filled with exotic
plants and flowers that encircle a serene
pond. Walk a winding path that takes
you past a stone garden and a salt
marsh. And don't forget to meditate!

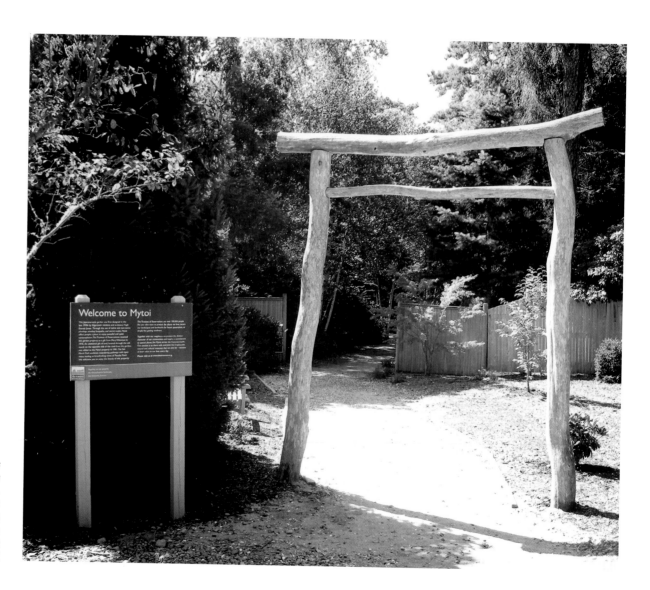

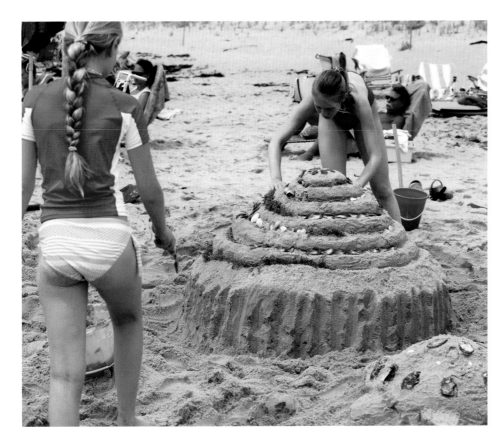

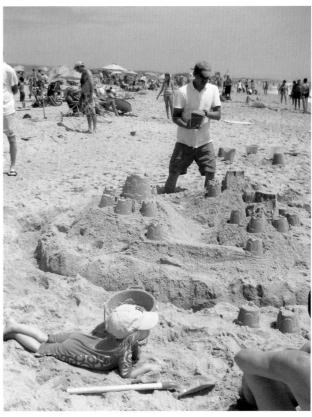

No. 71

Show off your creative side by building a sand castle

Building Sand Castles
South Beach

There's lots of room on this three-mile beach, and lots of sand. Show off your creative side with a couple of plastic buckets and plastic shovels, and build a fantastic sand castle. You might want to practice, because each August South Beach is home to Martha's Vineyard's Sand Sculpture Contest. The contest has divisions for adults and kids, so get busy planning.

No. 72

Take a bus to Aquinnah, admire the views along the way, and visit the native Wampanoag Tribe's shops

Wampanoag Tribal Shops
27 Aquinnah Circle, Aquinnah

For a relatively cheap do-it-yourself tour, jump on an island bus heading to Aquinnah. You'll be rewarded with fantastic views of the ocean and the island farms along the way, and then you'll get to check out the clay cliffs and the tribal shops in Aquinnah. The ancestors of the Wampanoag Tribe have lived in Aquinnah for at least 10,000 years, and the little shops on the cliff's edge are part of tribal culture. Spend a little time shopping for local crafts, and get a bite to eat. Then venture down the cliffs for the best views on Martha's Vineyard. Tip: Wonderful views of the cliffs and the lighthouse can also be found on the viewing platform tucked away behind the shops!

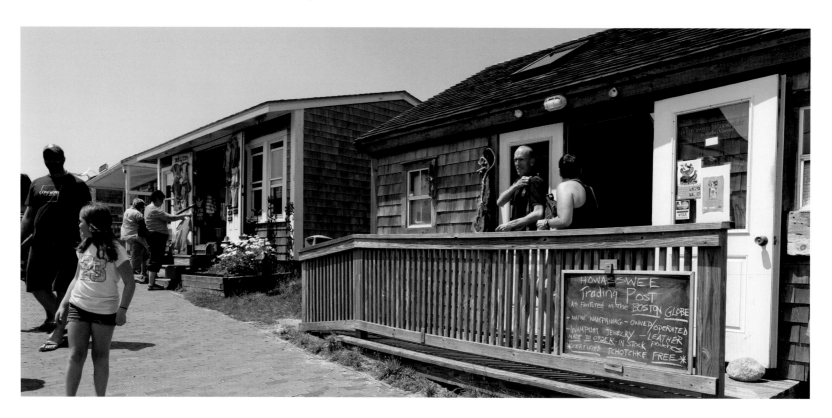

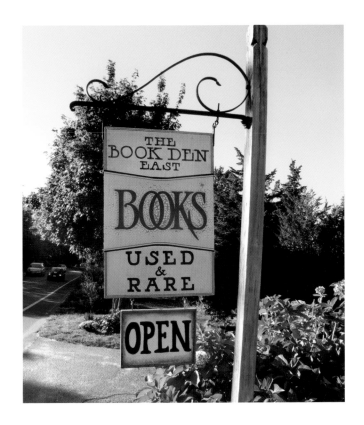

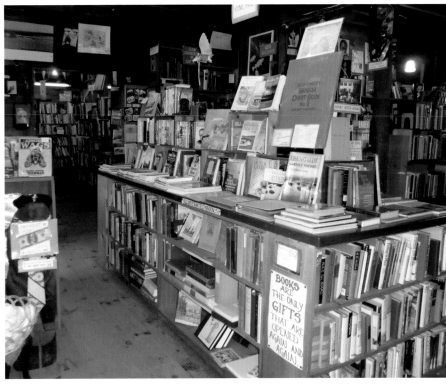

No. 73

Search out a rare book in one of the many cramped little bookshops on the island

Book Den East
71 New York Avenue, Oak Bluffs
508-693-3946

Although you may have brought along a book from one of those big chains back on the mainland, don't miss out on the chance to meander around inside one the island's tiny, cramped, independent bookstores. You will find wonderful local island books, rare books on sailing and marine life, and other dusty gems. Happy hunting!

No. 74
Get out on the water, and try your hand at paddle boarding, kite surfing, jet skiing, or windsurfing

Paddle Boarding, Kite Surfing, Jet Skiing, and Windsurfing
Nantucket Sound & Sengekontacket Pond, Edgartown

The Vineyard is a water sports paradise. Bring along your equipment, or you can rent and take lessons from one of the many shops on the water. While the action is excellent all over the island, most of the surfers seem to flock to the State Beach area along Beach Road. Sengekontacket Pond's waters are shallow and great for windsurfing and paddle boarding, while on the other side of the road, Nantucket Sound always has the wonderful breeze needed by kite surfers. And they are just plain ol' fun to watch as well.

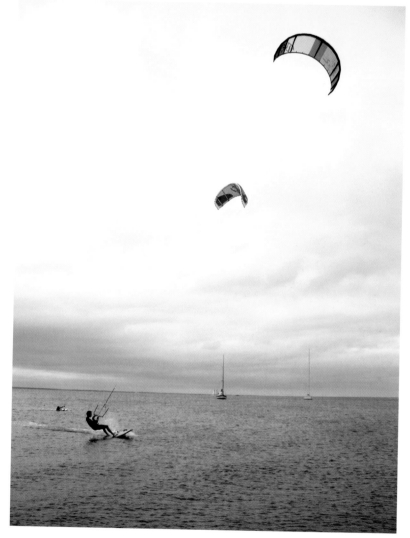

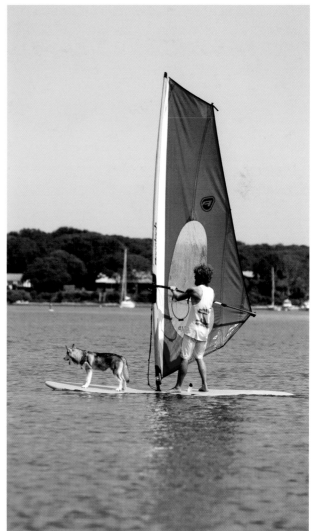

No. 75

Take the kids for a pony ride at the Red Pony Farm out near the airport

Red Pony Farm
85 Red Pony Road, West Tisbury
www.redponyfarmmv.com

What kid wouldn't love the chance to ride a real pony? The Red Pony Farm in West Tisbury is just the place to make that happen. From gentle rides for the novice to weekly programs for the more adventurous and advanced training for the equestrian, the farm has something to offer every horse lover. Their stables abut 5,000 acres of conservation land, which translates to excellent trail riding.

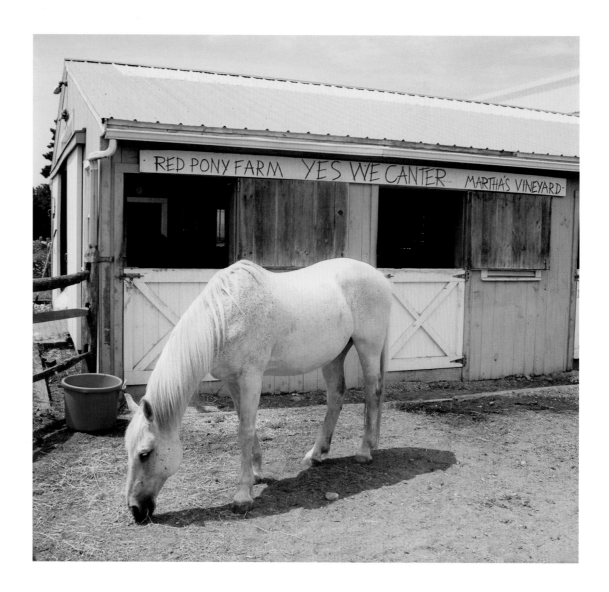

No. 76

Wait until the sun sets,
then take the scary Vineyard
Ghosts Walking Tour

Vineyard Ghosts Walking Tour
Edgartown | 774-563-0762

Intrigued by the mysterious and the paranormal? Then join Gary Cook (pictured in the orange shirt) and Karen Altieri (next to Gary) as they lead lantern-lit, nightly walking tours through the streets and alleys of Martha's Vineyard. They'll share their stories of mystery, legends, and most importantly . . . ghosts! If you're in need of some great nighttime entertainment, take the Vineyard Ghosts Walking Tour and learn all about the spirits that roam among the living. Tip: The tours meet at different locations on different days, so check out the current Vineyard Ghosts Walking Tour schedule for details.

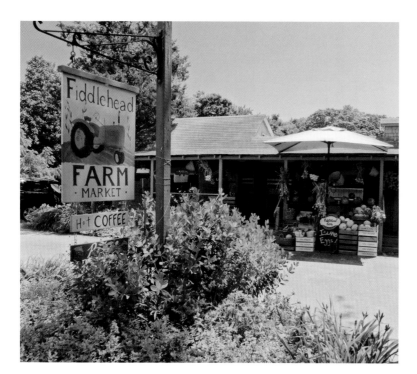

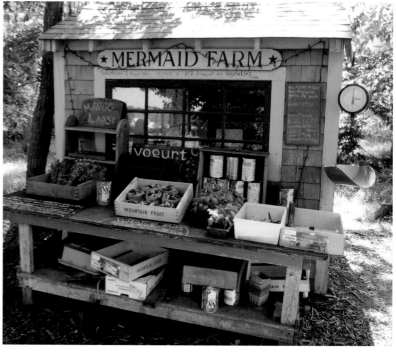

No. 77

Eat healthy by shopping for fruits and vegetables at one of the country-style farm markets on the island

Fiddlehead Farm Market
632 State Road, West Tisbury
www.fiddleheadfarmstand.com

Not only a great stop for lots of good locally grown produce, the Fiddlehead Farm Market at 632 State Road in West Tisbury is also a charcuterie and specializes in tasty artisanal cheeses as well. You'll find lots of high-quality stuff through the swinging doors of this old farmhouse, including homemade pies and some very good baguettes.

Mermaid Farm & Dairy
9 Middle Road, Chilmark
508-645-3492

Founded in 1997, Mermaid Farm is a thirty-five acre family-run farm in Chilmark. They have a super-cool tiny stand that features vegetables, herbs, dairy, and flowers. Inside the stand is a little fridge packed with feta, raw milk, lassis, and dairy. They are known throughout the island for their lassis, which are yogurt-based drinks that originated in India. Delicious!

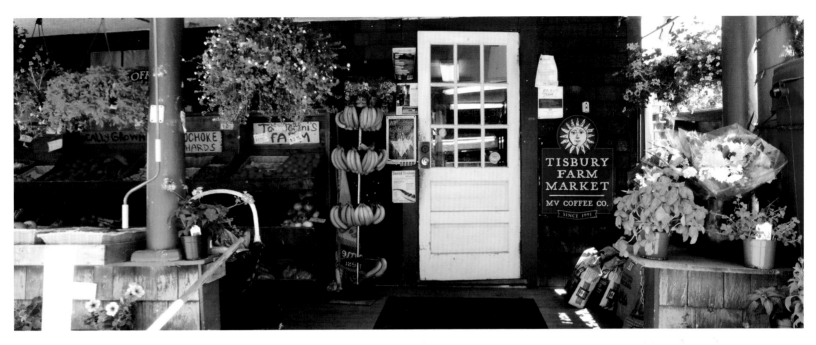

Tisbury Farm Market
294 State Road, Vineyard Haven
www.tisburyfarmmarket.com

This quaint local farm market always has an abundance of fresh, locally grown fruits, vegetables, plants, and flowers decoratively displayed "country-style" out front. Inside, the market boasts a butcher shop and has lots of healthy organic items, supplements, and a complete kitchen. It's the sister store to Vineyard Grocer, located just a few doors down the street.

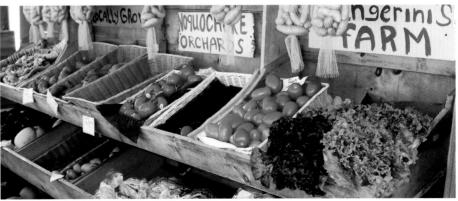

No. 78

Grab a twelve pack at Al's Package Store and call it a day!

Al's Package Store
258 Upper Main Street, Edgartown | 508-627-4347

Drive around anywhere on Martha's Vineyard and over and over again you'll see Al's famous bumper sticker. If you live on the island, chances are you've shopped at Al's. Repeatedly. Al's is the popular stop for cold alcoholic beverages, complete with a walk-in beer cooler.

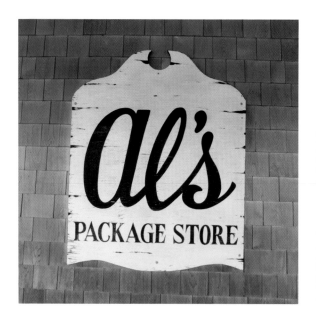

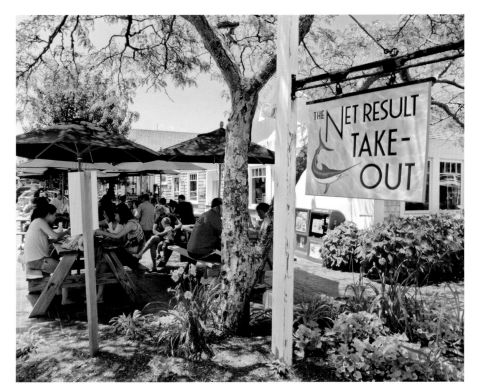

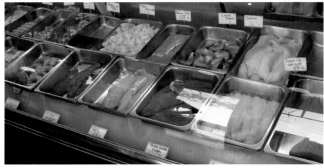

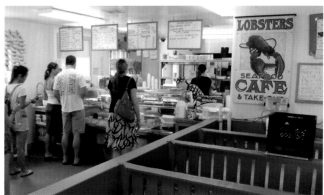

No. 79

Choose a live lobster from the tanks, then enjoy lunch outside on the picnic tables at The Net Result Fish Market

The Net Result Fish Market & Take-out
79 Beach Road, Vineyard Haven | www.mvseafood.com

Located in the Tisbury Marketplace at 79 Beach Road, The Net Result just might be one of the more affordable seafood places around. They advertise themselves as "an upper-scale fish market" with lots of fresh fish, sushi and take-out (they also offer shipping). But the best part is being able to pick out your lobster from the in-store tanks, and then enjoy your meal out on the picnic tables with the harbor in the distance. You could also feast on all types of fresh fish, hot butter lobster rolls, chowder, crab cakes, and more. Go early, as the tables fill up fast.

No. 80

If it's Tuesday, get out to the Featherstone Flea & Fine Arts Market off Barnes Road

Featherstone Flea & Fine Arts Market
30 Feather Stone Road, Oak Bluffs
www.featherstoneart.org

In the far reaches of Oak Bluffs off Barnes Road, you'll find a huge, popular flea market at the Featherstone Center for the Arts. Spread out over a green lawn, this Tuesday afternoon affair features lots of tents and stands filled with local jewelry, art, clothing, and every craft imaginable. Bargains abound.

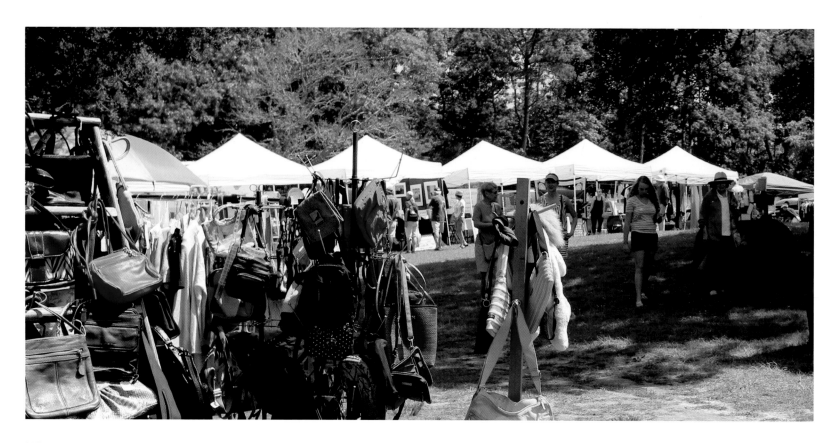

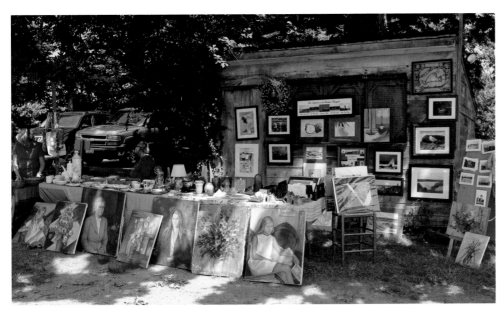

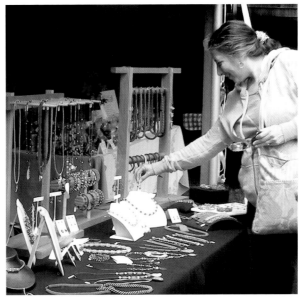

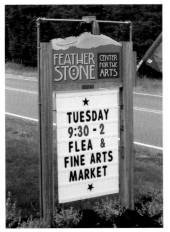

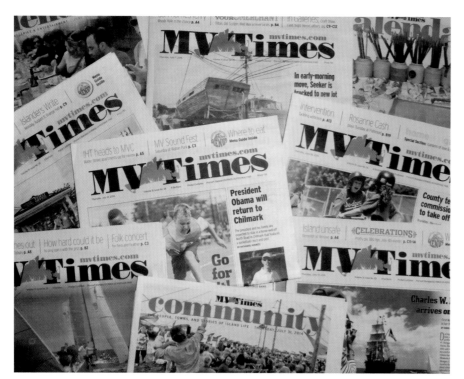

No. 81

Check out the weekly publication MV Times for local events and essentials

MV Times
Available throughout Martha's Vineyard | www.mvtimes.com

To make the most of your visit, be sure to pick up a copy of the *MV Times* upon your arrival. Or better yet, check them out online before you arrive. Much more than just local news, the paper will put you in-the-know with all the current activities and events taking place on the island. They always have lots of great suggestions and articles on shopping, dining, drinking, and great ways to just have fun during your visit. The calendar section of the paper will tell you everything you need to know about current essentials on the island. Tip: Also pick up *The Vineyard Gazette*. Although it looks like more of a local newspaper, it does contain helpful tourist information and articles on current happenings.

No. 82

Enjoy some sushi while looking out over the ocean at Lookout Tavern in Oaks Bluff

Lookout Tavern
8 Seaview Avenue, Oak Bluffs | www.lookoutmv.com

This aptly named, newly renovated tavern has some of the best sushi on the island. Of course, it also has a full menu with tavern fare and fried seafood, but its raw fish rules the day. Sit on the open-air deck with a cold beer, and look out over the incoming and outgoing ferries on Vineyard Sound.

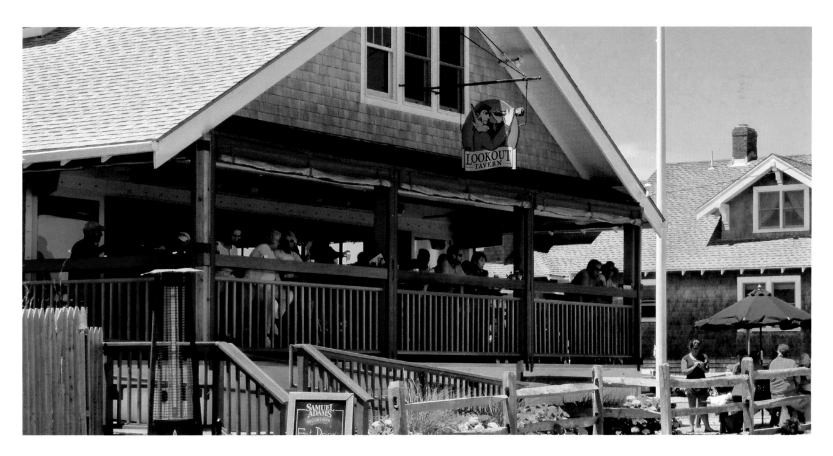

No. 83

Go to a world-class dance performance at The Yard in Chilmark

The Yard Performance Center
Off Middle Road near Beetlebung Corner, Chilmark | www.dancetheyard.org

If you have a chance to experience one of these world-class dance performances when you're on the island, don't miss it! Located out near Beetlebung Corner in Chilmark and founded in 1973, The Yard is a wonderful dance and performance center known for encouraging contemporary dance artists to develop new works. Tip: Come early and relax on their charming little outdoor stone patio surrounded by trees and flowers! You'll find it as welcoming as their friendly staff.

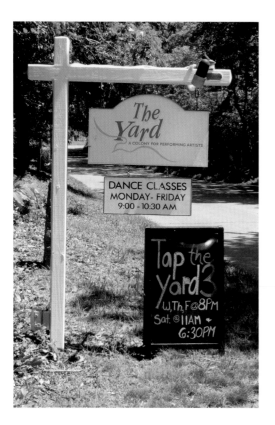

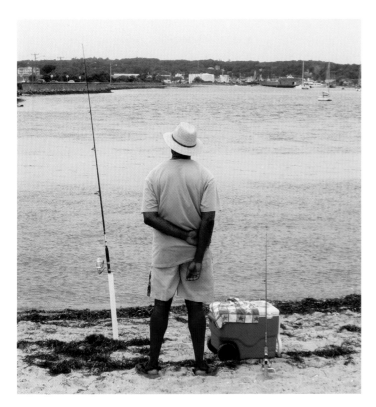

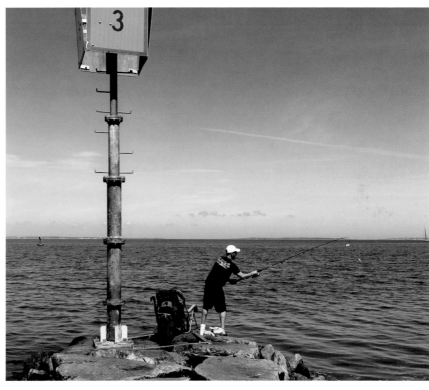

No. 84

Rent a pole, and go fishing at the local favorite spots in Wasque or Menemsha

An Unknown Fisherman
Vineyard Haven

There are many fine spots on the island to throw out a line, including Vineyard Haven, but if you really want to haul in a nice catch, you probably will do best to fish where the locals do, like in Wasque, which gets pretty wild when the fishing is hot, or in Menemsha, which they say is the best place for bonito and fluke.

Erik at his Favorite Spot
Menemsha

Many locals will tell you they have the most fishing success in Menemsha, including Erik, who enjoys the crystal clear waters at the far end of the long stone jetty. And talk about a favorite spot—he's been fishing here since he was two! Tip: Menemsha is also known as a great place for night fishing.

No. 85

Visit the nature center, and walk the four miles of meadow trails at Felix Neck Wildlife Sanctuary

Felix Neck Wildlife Sanctuary
Off Edgartown-Vineyard Haven Road, Edgartown | 508-627-4850

Here's another great opportunity to be up close with Mother Nature. Felix Neck is a 219-acre sanctuary for both wildlife and people, with four miles of trails twisting through thick woodlands, open meadows filled with wild flowers, salt marshes, and ponds. Many of the species of birds that flock to the island can be spotted in this tranquil preserve. The Audubon Society offers lots of great summer programs, classes, and activities for the whole family. You can join a group or hike alone, just remember to bring the mosquito repellent!

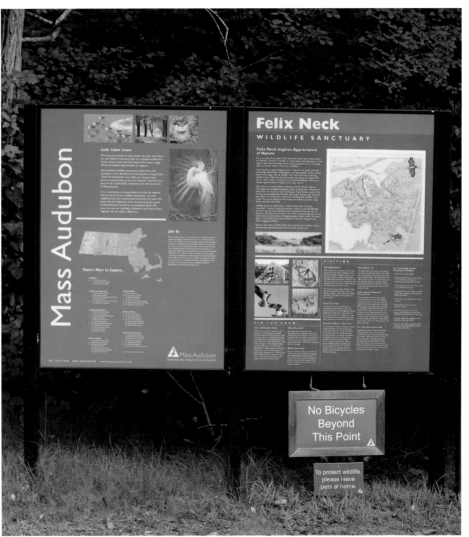

No. 86

Hunt for treasures at an island antiques shop

Pyewacket's Antiques & Magick
135 Beach Road, Vineyard Haven | 508-696-7766

Antiquing is an art form here on Martha's Vineyard, and fascinating antiques shops are scattered all over the island. There seems to be one down every side street; there are even shops set up in front of some homes. Stuffed with antique hardware, folk items, and old Vineyard memorabilia, you'll definitely need to set aside a little time to hunt for your own timeless treasure.

Over South Antiques & Collectibles
8 Basin Road, Menemsha | 508-645-3378

Just like an antique, this tiny shop owned by Jane Slater for the last thirty-nine years is a gem waiting to be discovered. It's packed with all kinds of rare and extraordinary items, from old fishing traps to vintage plates, cups, and saucers. Definitely worth the stop when you are in Menemsha.

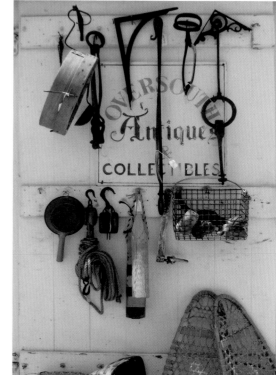

No. 87

Feel the healing energy and participate in farming activities at the Native Earth Teaching Farm

Native Earth Teaching Farm
94 North Road, Chilmark | www.nativeearthteachingfarm.org

Out in the rural part of the island, the Native Earth Teaching Farm is a small working farm, specializing in farm education and recreational farm activities, with a wonderful emphasis on restoration and healing. Their focus is on raising the healthiest of foods in their thriving community garden and sharing their knowledge and experience with the community. Stop in and help feed the goats, pigs, chickens, and sheep. You can learn from one of their many classes or watch a demonstration of farm crafts. They even have a Friday night campfire.

No. 88

Avoid the crowds at South Beach by spending your afternoon on one of the many other smaller beaches on the island

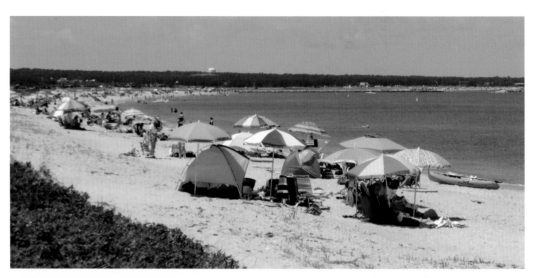

Joseph A. Silva State Beach
Edgartown

Known simply as "State Beach," this two-mile stretch of sand runs along Beach Road all the way up to Oak Bluffs. It's on the side of the island that faces Nantucket Sound, so it's blessed with gentle waves and shallow, warmer waters, making it ideal for swimming. Parking is free, it's close to two major towns, and the shuttle bus stops here, so this beach generally fills up pretty fast. State Beach is also home to the famous wooden bridge seen in the movie *Jaws* that visitors and islanders alike have been jumping off for years.

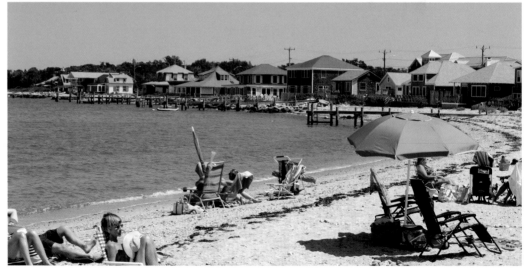

Eastville Beach
Oak Bluffs

This quiet little beach with a gentle surf goes somewhat unnoticed. It's neatly tucked right off the new drawbridge that connects Oak Bluffs and Vineyard Haven. Relaxing on the soft sand, you'll be facing Vineyard Haven Harbor, which makes Eastville Beach the ideal spot for watching the ferry and the sailboats coming and going. It's also a great spot for fishing and water sport activities like kite surfing and jet skiing.

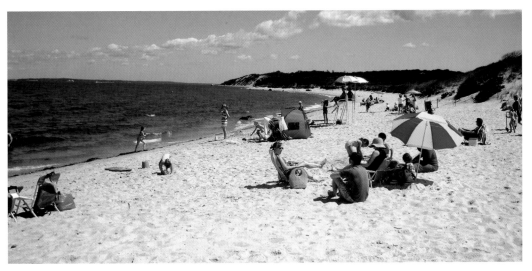

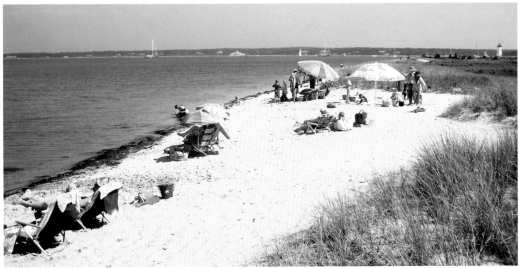

Lambert's Cove Beach
West Tisbury

Although this beach is restricted to town residents, in-season renters, or those who purchase a walk-on pass, I just had to mention this secluded sandy gem. Lambert's Cove has the finest sand and the clearest blue water on island, but it's the rolling sand dunes that appear after a short walk on the winding path through the woods that make this place magical. The tremendous views of the water, the surrounding scenery, and the peaceful quiet make this a great spot for just strolling along the water's edge. Many folks do consider this the top beach on the island.

Fuller Street Beach
Edgartown

If you like seclusion, this is your kind of beach. Located at the very end of Fuller Street in Edgartown, the beach is flanked by beautifully appointed mansions and a great view of the Edgartown Lighthouse. Parking is virtually nonexistent, so it's best to search out this spot by foot or on bike. The shore is shallow and rocky, so this beach is not really very good for swimming. But it's probably the best spot if you're looking for seashells. Visit in the early morning hours and the sand will be littered with colorful scallop shells (and little old women with plastic shell buckets).

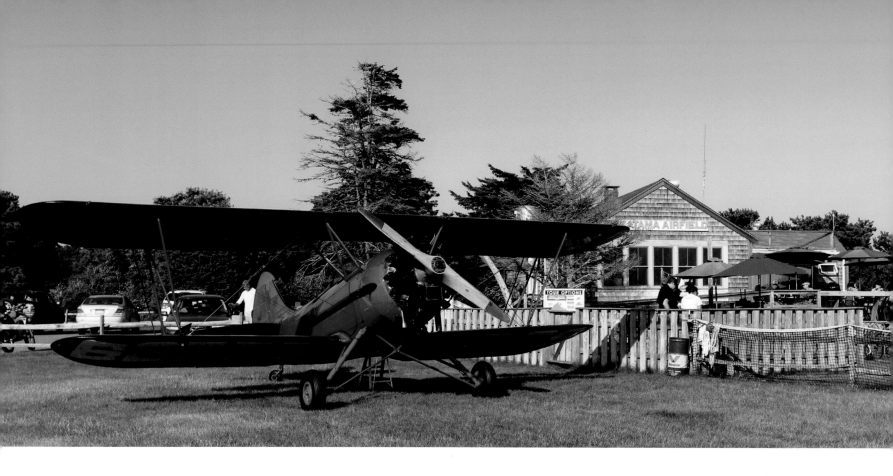

No. 89

Strap on your goggles, and view the island from the air in a classic vintage two-seater biplane

Classic Aviators LTD
Katama Airfield, 12 Mattakesett Way, Edgartown | www.biplanemv.com

For one of the biggest thrills on the island, try an airborne sightseeing tour operated by Classic Aviators at Katama Airfield out by South Beach. Flying out of Katama Airfield is like going back to the roots of aviation. Strap on a leather cap and matching goggles and hop into an open-air cockpit. The classic vintage biplane takes off from a grassy airfield and flies right over the beach. With the wind blowing on your face, you'll experience the most awesome views of the island. It's a tour you will surely never forget!

No. 90

Show off your putting skills at Island Cove Mini-Golf

Island Cove Mini-Golf
386 State Road, Vineyard Haven | www.islandcoveadventures.com

Located on State Road right across from the Cronig's Market, Island Cove is a quaint little course that's a must-stop for some serious family-friendly fun. It seems like every youngster celebrating a birthday ends up here. The course is small but challenging, complete with caves, bridges, and waterfalls. Tip: They also have good ice cream and a rock climbing wall out back alongside the parking lot!

No. 91

If it's Wednesday night, join in Community Sings at the huge open-air Trinity Park Tabernacle in Oak Bluffs

Community Sings
Trinity Park Tabernacle, Oak Bluffs | www.mvcma.org/events/community-sings

If it's 8 p.m. on Wednesday night, it's time to sing! For over 100 years, large crowds of neighbors and tourists alike have been filling the Trinity Park Cathedral in the heart of the Martha's Vineyard Camp Meeting Association's Wesleyan Park. Encircled by rows of colorful gingerbread cottages, this elegant, wrought-iron outdoor tabernacle built in 1879 chimes with hymns, folk songs, spirituals, rounds, and patriotic songs. It really is a lot of fun. It might sound corny, but it's a must-do if you're here on a Wednesday night in July or August.

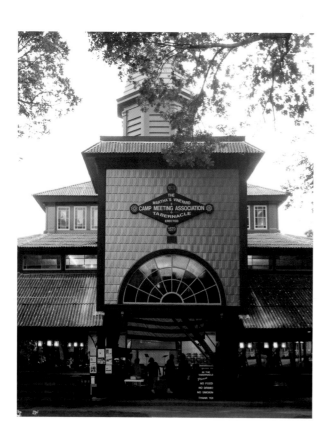

No. 92

Check with the shellfish warden to get a permit . . . then dig for clams!

Digging for clams in Sengekontacket Pond
Off Beach Road, Edgartown

If you have a yearning for some fresh linguini and clams when you are on the island, get a permit, grab your rubber boots and clam rack, and head out to Sengekontacket Pond. The pond stretches from Edgartown to Oak Bluffs and is known to be the best place for clamming. The clams (and oysters) are only buried in a couple of inches of sand or mud, so they're fairly easy to find, especially during low tide. Dig in, then enjoy your feast!

No. 93

Enjoy a frozen treat from the Shave Ice truck parked across the street from the ocean on Beach Road

Shave Ice Truck
Off Beach Road along State Beach,
Oak Bluffs

A great way to cool off on a summer's afternoon is a refreshing shaved ice from the colorful truck parked just off the road facing State Beach. Two of the more popular shaved ices are the Beach Bum, a watermelon-lemonade combo, or the Shark Attack, which is blue raspberry and cherry topped with a gummy shark. Tip: The truck is also one of the few places on the beach where you can rent or buy a beach chair.

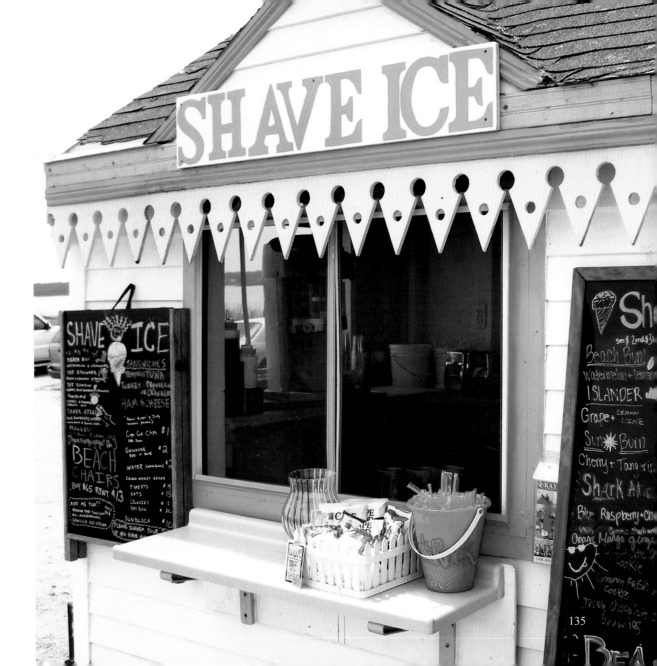

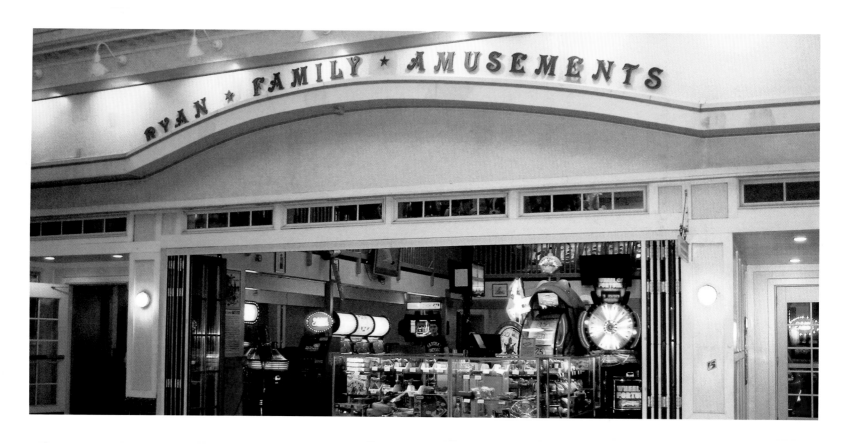

No. 94

Play the arcade games at Ryan Family Amusements on Circuit Avenue in Oak Bluffs

Ryan Family Amusements
19 Circuit Avenue, Oak Bluffs | www.ryanfamily.com

There's nothing like a colorful arcade full of big noisy games to keep the kids busy for hours! Shoot some pirates, play Guitar Hero, try your luck at skeeball, or challenge a friend to air hockey. The Ryan Family Amusements has seventy-five of the coolest arcade games to test your skills. And that steady stream of paper tickets spilling from a victorious machine just adds to the excitement. Those tickets add up fast, and great prizes await behind the glass display cases!

No. 95

Jump on the Steamship Authority ferry, and take a day trip to Woods Hole or Falmouth

Steamship Authority Ferry
Two terminals: 1 Water Street in Vineyard Haven or 1 Seaview Avenue in Oak Bluffs
www.steamshipauthority.com

Although there is plenty to do on the island, you don't want to miss out on visiting the quaint towns of Woods Hole and Falmouth back on the Cape. If you're here for a while, jump on a ferry and explore for an afternoon. If you're here for a day, stop and check out one of the towns for a few hours before returning home. A bonus: you will find that some of the best views of Martha's Vineyard's coastline can be had from the upper deck of the huge vessel. Tip: If you are driving to catch the ferry to Martha's Vineyard, park in the Palmer Avenue lot in Falmouth. There is no parking in Woods Hole.

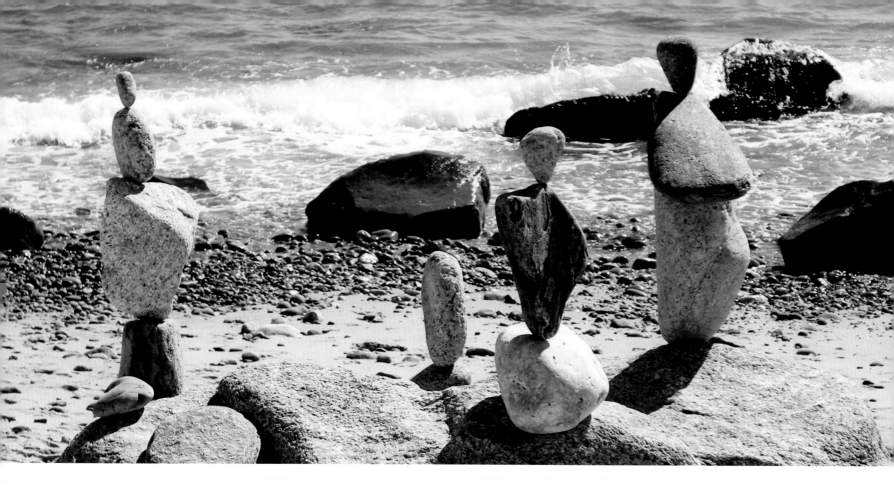

No. 96

Go to the beach to practice the fine art of rock balancing

Rock balancing on Moshup Beach
Moshup Beach, Aquinnah

Rock balancing might be considered art or just plain fun, depending upon the intent of the practitioner. Walk around any of the beaches on the island, especially Moshup Beach where the smooth stones are plentiful, and you are sure to spot a delightful stretch of well-balanced rocks. It is harder than it looks, but go ahead and give it a try. It's a great way to spend the afternoon in the sun.

No. 97

Send a loved one some homemade fudge from one of Murdick's Fudge Shops

Murdick's Fudge Shops
Oak Bluffs, Vineyard Haven and Edgartown | www.murdicks.com

If you're strolling around any of the island's three major towns and a delicious smell wafts by, chances are it's coming from one of Murdick's Fudge shops. They've been making fresh homemade fudge, peanut brittle, and chocolate nut clusters with the same recipes since 1887. Highly recommended fudge flavors: Cape Cod Cranberry or Penuche (maple syrup with walnuts). Better yet, try them all!

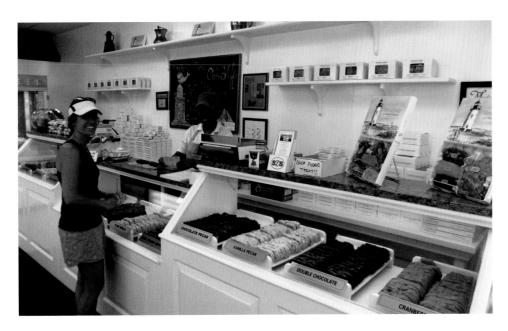

No. 98

Get delicious homemade ice cream from Mad Martha's Ice Cream or Ben & Bill's Chocolate Emporium

Ben & Bill's Chocolate Emporium
20 Circuit Avenue, Oak Bluffs
www.benandbills.com

Ben & Bill's Chocolate Emporium has created quite a reputation for having some of the most flavorful varieties of ice cream on the island. Strategically located on Circuit Avenue in Oak Bluffs, this loud and colorful parlor also has tons of homemade candies on display. But come for the creamy cold stuff, and don't leave until you've tried the lobster-flavored ice cream!

Mad Martha's Ice Cream
7 North Water Street, Edgartown
508-627-8761

Since 1971, Mad Martha's has been dishing out homemade ice cream. Located in all three of the major towns Down-Island, expect to wait in long lines during the summer just to enter the crowded parlors. But it's worth the wait; especially for the Sinful Chocolate or blueberry ice cream flavors.

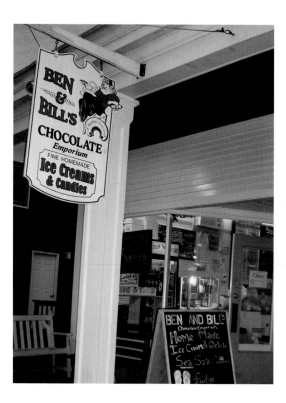

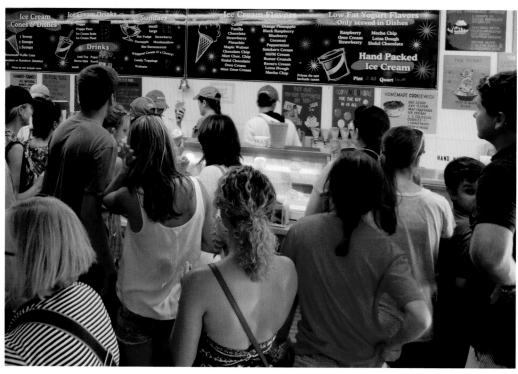

No. 99

Discover the extraordinary range of plants that are grown on Martha's Vineyard at Polly Hill Arboretum

Polly Hill Arboretum
809 State Road, West Tisbury | www.pollyhillarboretum.org

A fantastic place to appreciate nature, this seventy-acre former sheep farm is adorned with a colorful mix of almost 3,100 native and exotic plants. They have all been collected from seedlings and nurtured by the late horticulturist Polly Hill. These rare trees and shrubs from around the world are beautifully set among stone walls, meadows, and fields. Be sure to check out the monkey puzzle trees. The national tree of Chile, the monkey puzzle looks like a cross between a cactus and an evergreen. Wild!

No. 100

Shop for world-famous Black Dog logo souvenir items at the Black Dog General Store

The Black Dog General Store
5 Water Street, Vineyard Haven | www.theblackdog.com

The Black Dog chain started out as a restaurant in 1971, but it is probably better known across the country today for its colorful hats and T-shirts with the infamous black Lab proudly standing front and center. Nothing says "I've been to Martha's Vineyard" more than Black Dog apparel. So before you board the ferry in Vineyard Haven, grab a coffee, grab a pastry, and grab a Black Dog souvenir. Trust me; you'll be glad you did!

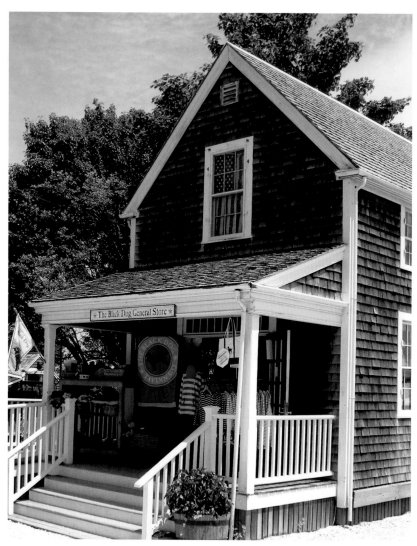

No. 101

Get up early, realize you're on vacation,
and go back to bed!

SWEET DREAMS AND HAPPY TRAVELS!

101 THINGS TO DO

(IN A HANDY LIST)

For your convenience, here's a quick-look reference list of all the ideas in this book. Check off as many as you can each time you return to the island! And keep in mind, the list is in no particular order. I haven't put the "best" things first; each is wonderful in its own right. Also, some of the activities may be held only weather-permitting or held at certain, scheduled times, so please check ahead for current updates and availabilities. I hope you get to experience them all, and that your vacation will be memorable!

1. Find a romantic bed and breakfast and spend the night

2. Toss a Frisbee, fly a kite, or play ball on the huge great lawn known as Ocean Park

3. Jump in the waves, or just simply get a tan at South Beach, the island's most popular three-mile beach

4. Grab your camera, then try to photograph all five lighthouses on the island

5. Enjoy a generous lobster roll on Fridays at Grace Church in Vineyard Haven, a local favorite

6. Go for a jog along the ocean on East Chop Drive in Oak Bluffs

7. Order the famous Dirty Banana from Donovan at Donovan's Reef overlooking Oak Bluffs Harbor

8. Take a narrated tour of the island on the Martha's Vineyard Sightseeing Bus

9. Find a quiet, peaceful spot, and read a good book

10. Stroll the harbors to check out all the huge, multi-million-dollar yachts docked on the water

11. Ride the Flying Horses Carousel, and try to grab the brass ring

12. Visit one of the many local nurseries and plant something

13. Make an appointment to pick your own blueberries at Murphy's Blueberry Farm in Chilmark

14. Hike the scenic clay cliffs of Aquinnah, a.k.a. Gay Head Cliffs

15. Walk through the colorful village known as "The Campground" with more than 300 ornate, tiny gingerbread cottages

16. Admire the boats in Edgartown Harbor, one of the most beautiful harbors in the world

17. Get a good old-fashioned breakfast at the Art Cliff Diner, another local favorite

18. Take the old three-car "On Time" ferry to Chappaquiddick, and drive around Chappy trying to spot the Kennedys!

19. Get a great cup of coffee at either Espresso Love or Mocha Mott's coffee shops

20. Collect some exotic seashells from the secluded beach at the end of Fuller Street

21. Take a walking tour of the old dignified whaling captains' mansions along the harbor in Edgartown

22. Follow a rickety path along the dunes

23. Enjoy some fresh seafood and a refreshing ocean breeze at a waterfront open-air raw bar

24. Create your own freshly picked garden salad from the salad bar at the Morning Glory Farm

25. Grab a bite to eat at the original Black Dog Tavern in Vineyard Haven

26. Go for a sunset sail on the ocean aboard the Mad Max catamaran or the Black Dog Tall Ships

27. Play eighteen holes of golf at Mink Meadows in Vineyard Haven

28. Shop for shoes . . . mostly shoes!

29. Hang out with the locals, and drink beer at The Wharf Pub in Edgartown

30. Rent a bike in Oak Bluffs, and ride the six-mile bike path along the ocean to Edgartown

31. Hike down the cliffs, and enjoy a beautiful day on Moshup Beach in Aquinnah

32. Grab a glass of wine or a martini and sit on a rocking chair admiring the harbor at the posh Harbor View Hotel

33. Collect some beautiful multicolored stones along the beach in Menemsha

34. Watch glass blowing at Martha's Vineyard Glassworks in West Tisbury

35. Try to catch one of the many wild turkeys running free on the island

36. Enjoy the hand-crafted beer and drop peanut shells on the floor at the Offshore Ale Brewery in Oak Bluffs

37. Get a fresh, hot doughnut through the kitchen door until 12:59 a.m. at Back Door Donuts

38. Go for a nature hike up to Prospect Point in Menemsha Hills Reservation, one of the highest elevations on the island

39. Rent a moped and visit all three major towns—Edgartown, Oak Bluffs & Vineyard Haven—in one afternoon

40. Go to the movies at one of the island's historic theaters: the Strand, Island Theatre, or Edgartown Cinemas

41. A must-do: get a steamed lobster at Larsen's Fish Market then watch the sunset on the beach in Menemsha

42. Don't forget to take a bottle of wine to sunset!

43. Rent a Jeep, get an over-sand permit, and go crazy riding the dune trails just off South Beach

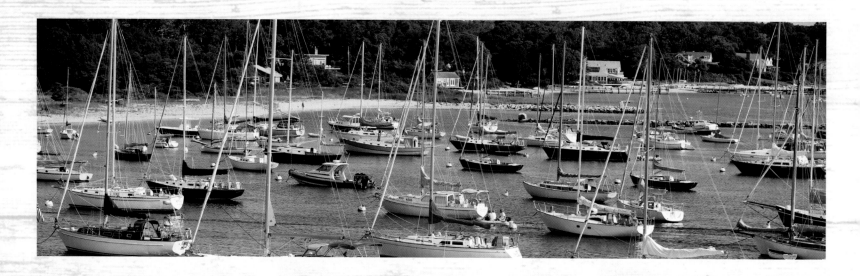

44. Get yourself a bike, and ride the ten-mile loop in and around Manuel F. Correllus State Forest

45. Hike the trails around the Mayhew Chapel and Indian Burial Grounds in West Tisbury

46. Visit the Vincent House, the oldest residence on the island, built in 1672

47. Mix-n-match your favorite homemade candies at Chilmark Chocolates

48. Check out the artful creations at the Field Gallery & Sculpture Garden in West Tisbury

49. Go see the alpacas, and take the tour of the nineteen-acre Island Alpaca Farm

50. Enjoy the island's best breakfast sandwich or pick out a yummy pastry at the Scottish Bakehouse in Tisbury

51. Have a slice of pizza, and watch for famous faces from a front-porch rocking chair at Chilmark General Store

52. Learn about sustainable agriculture and play farmer at The Farm Institute near Katama Airfield

53. Hang out at the bars and restaurants overlooking the boats in the harbor at the Oak Bluffs Dockside Marketplace & Marina

54. Shop at the galleries and boutiques in the Arts District along Dukes County Avenue in Oak Bluffs

55. Photograph the famous pagoda tree, the oldest on the continent, planted in 1837

56. Look in awe at the more than 30,000 items in the Martha's Vineyard Museum

57. Have a ton of fun out on the ocean on a booze cruise

58. Rent a kayak or a canoe from Winds Up! on Beach Road, and paddle the day away

59. Go see live professional theater at the Martha's Vineyard Playhouse in Vineyard Haven

60. Enjoy a Dark 'n Stormy on the sunny second-floor deck at The Seafood Shanty in Edgartown

61. Take a late-afternoon stroll down Circuit Avenue in Oak Bluffs, and look into all the neat shops

62. Listen to some great live local music at the clubs and restaurants in Edgartown or Oak Bluffs

63. Go to the outdoor West Tisbury Farmers Market on Wednesdays or Saturdays

64. Pretend you're rich and famous by walking around inside one of the many fine-art galleries

65. Walk amongst the fishing boats in Menemsha, and see where the movie *Jaws* was filmed

66. Attend an outdoor yoga class with Rock outside Atria Restaurant in Edgartown

67. Visit one of the many turn-of-the-century general stores on the island

68. Rent your own sailboat, and sail into the sunset

69. Join the crowd jumping off the wooden drawbridge into the water at State Beach

70. Walk the footpaths of Mytoi Gardens, a fourteen-acre Japanese-style garden filled with exotic plants

71. Show off your creative side by building a sand castle

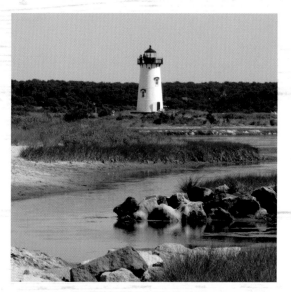

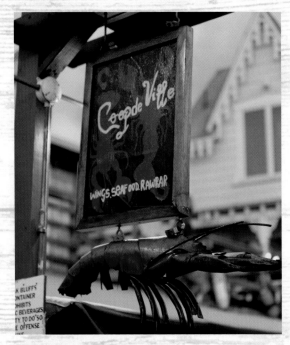

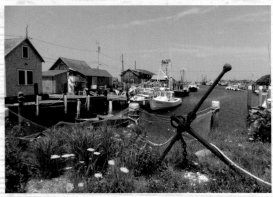

72. Take a bus to Aquinnah, admire the views along the way, and visit the native Wampanoag Tribe's shops

73. Search out a rare book in one of the many cramped little bookshops on the island

74. Get out on the water, and try your hand at paddle boarding, kite surfing, jet skiing, or windsurfing

75. Take the kids for a pony ride at the Red Pony Farm out near the airport

76. Wait until the sun sets, then take the scary Vineyard Ghosts Walking Tour

77. Eat healthy by shopping for fruits and vegetables at one of the country-style farm markets on the island

78. Grab a twelve pack at Al's Package Store, and call it a day!

79. Choose a live lobster from the tanks, then enjoy lunch outside on the picnic tables at The Net Result Fish Market

80. If it's Tuesday, get out to the Featherstone Flea & Fine Arts Market off Barnes Road

81. Check out the weekly publication *MV Times* for local events and essentials

82. Enjoy some sushi while looking out at the ocean at Lookout Tavern in Oaks Bluff

83. Go to a world-class dance performance at The Yard in Chilmark

84. Rent a pole, and go fishing at the local favorite spots in Wasque or Menemsha

85. Visit the nature center, and walk the four miles of meadow trails at Felix Neck Wildlife Sanctuary

86. Hunt for treasures at an island antiques shop

87. Feel the healing energy and participate in farming activities at the Native Earth Teaching Farm

88. Avoid the crowds at South Beach by spending your afternoon on one of the many other smaller beaches on the island

89. Strap on your goggles, and view the island from the air in a classic vintage two-seater biplane

90. Show off your putting skills at Island Cove Mini-Golf

91. If it's Wednesday night, join in Community Sings at the huge open-air Trinity Park Tabernacle in Oak Bluffs

92. Check with the shellfish warden to get a permit . . . then dig for clams!

93. Enjoy a frozen treat from the Shave Ice truck parked across the street from the ocean on Beach Road

94. Play the arcade games at Ryan Family Amusements on Circuit Avenue in Oak Bluffs

95. Jump on the Steamship Authority ferry, and take a day trip to Woods Hole or Falmouth

96. Go to the beach to practice the fine art of rock balancing

97. Send a loved one some homemade fudge from one of Murdick's Fudge shops

98. Get some delicious, homemade ice cream from Mad Martha's Ice Cream or Ben & Bill's Chocolate Emporium

99. Discover the extraordinary range of plants that are grown on Martha's Vineyard at Polly Hill Arboretum

100. Shop for world-famous Black Dog logo souvenir items at the Black Dog General Store

101. Get up early, realize you're on vacation, and go back to bed!

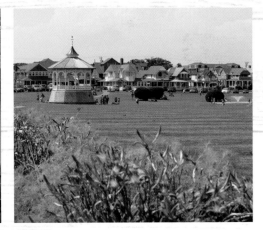

INDEX

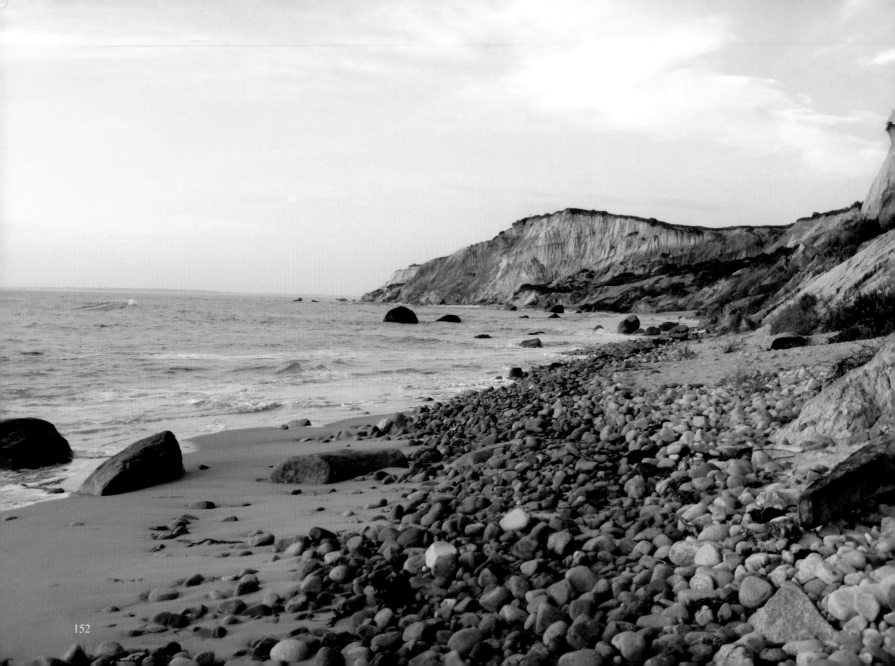